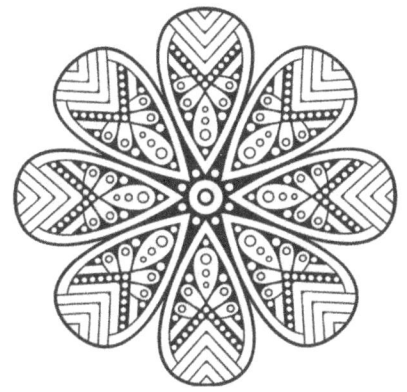

Mandala

An adult coloring book of Mandalas for stress relieving

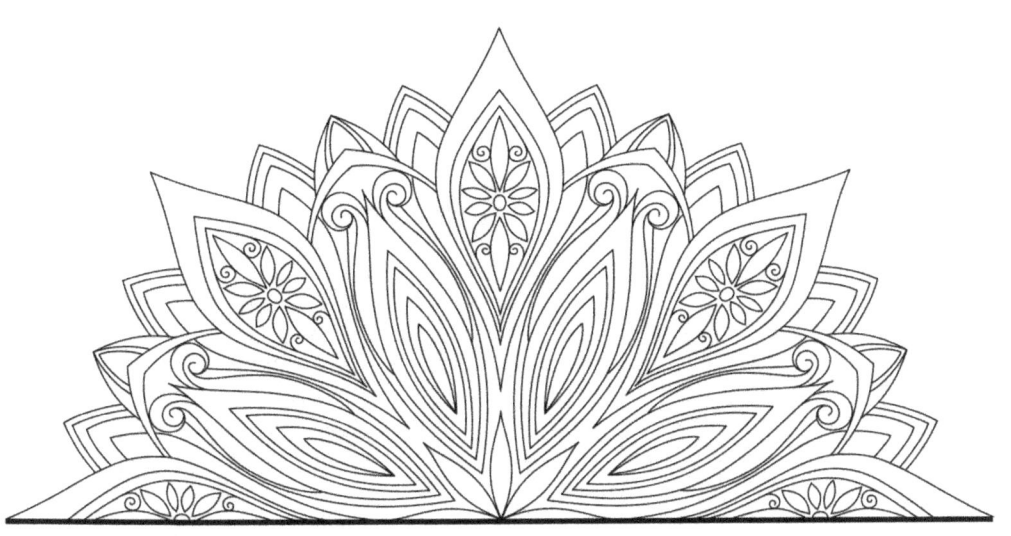

This book belongs to:

© Copyright 2016 - Pegasus Coloring Books
All rights reserved.
All images are either unique or have been licensed.
No part of this book may not be partially or entirely replicated or reproduced.

Introduction

Mandala means "circle" and "center" in the ancient Sanskrit language. The circular shapes of mandalas have the power to balance the energies of your body, promote relaxation & enhance your creativity.

The mandala is created from a centred point, from which everything is possible. Colouring a mandala means that you are in need to express your desire for healing and wellness.
Either you have a quest to restore your inner peace or you would simply like to express your artistic talent, the mandalas will help you achieve it.

Colouring is also a sweet reminder of our childhood where everything was simple and lighthearted. No matter how old you are, you will never be too old to color, and colouring books for adults have proven to be very beneficial to reduce anxiety and bring the mind to peace.

Colouring allows people to enter a meditative state where the being is all that matters. You do not need to be an artist, nor an expert to color. There will never be a good or bad, a right or wrong, but simply you, your design and crayons.

The mandalas have been carefully chosen for you to express whatever feelings you might have inside. It is a personal experience that you must do freely and judgment-free. You do not have to start from the illustration number one or start with a preset color. All you need is to be relaxed, take the color that you feel at the moment and start colouring.

We deeply hope that our mandalas will bring you calm and happiness and that you will benefit from them in as many ways as possible.

Coloring Advices

If you are a beginner or even this book is your first, then these few advises will probably be useful to begin. As you will see, there are no rules in colouring and it is a very personal art, but nevertheless, it is always pleasant to know some ground rules.

How to choose the best coloured pencils?

Pencils with hard and thin leads are the best to color your designs. A strong lead is important as you do not want it to break every time you spend more than 5 minutes on a color. The other important thing is to get ones that allow you to make beautiful shades and fades.
It is also more pleasant if they slide well on the paper as well as having a good grip. The round ones are more ergonomic in hand and therefore allow a nicer experience.

Finally, the last tip we can give you is to always have two sets of the same pencils, one with thin and well carved leads for very intricate designs and the other with rounder leads to color bigger spaces.

How to choose the best markers for your colouring book?

In General, you should avoid hard tips ones as they tend be poor quality and dry much faster. The best are the markers with thin tips and not so hard, pretty soft even as it will allow you to play with the shades and be precise for the most intricate ones. If your designs are even more intricate, then the extra thin tips can be an option for an enjoyable experience.

Finally, if the tip dried out entirely, do not throw it away. Simply dip it into 70% alcool which will give it a second life for a while.

Now, if you are heavy-handed, then it is important to take some precautions in order to prevent ruining the other beautiful designs. To do so, make sure that you put a sheet of paper behind the one you are doing, so that when the ink passes through it doesn't color the other designs.

Test Page

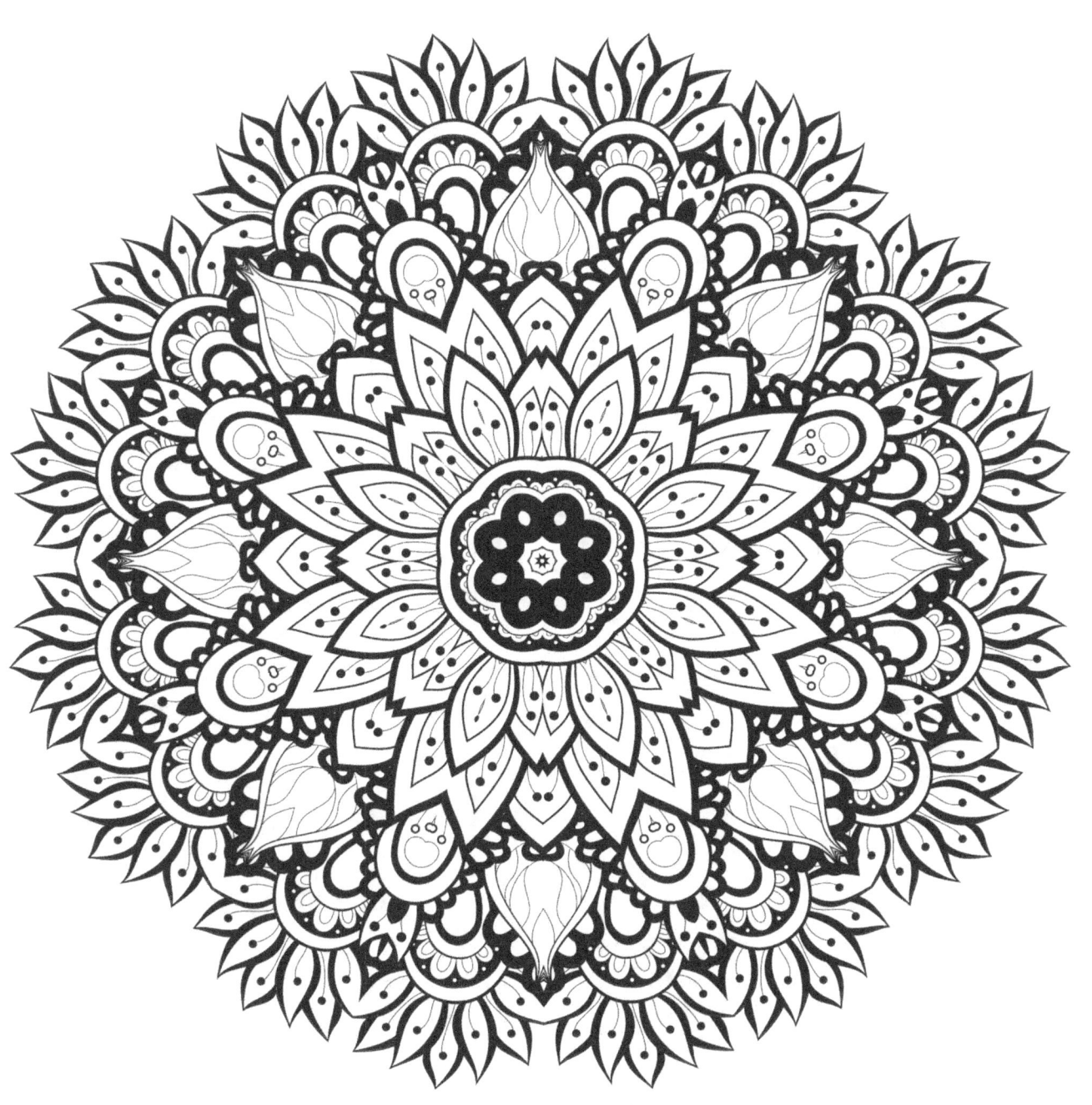

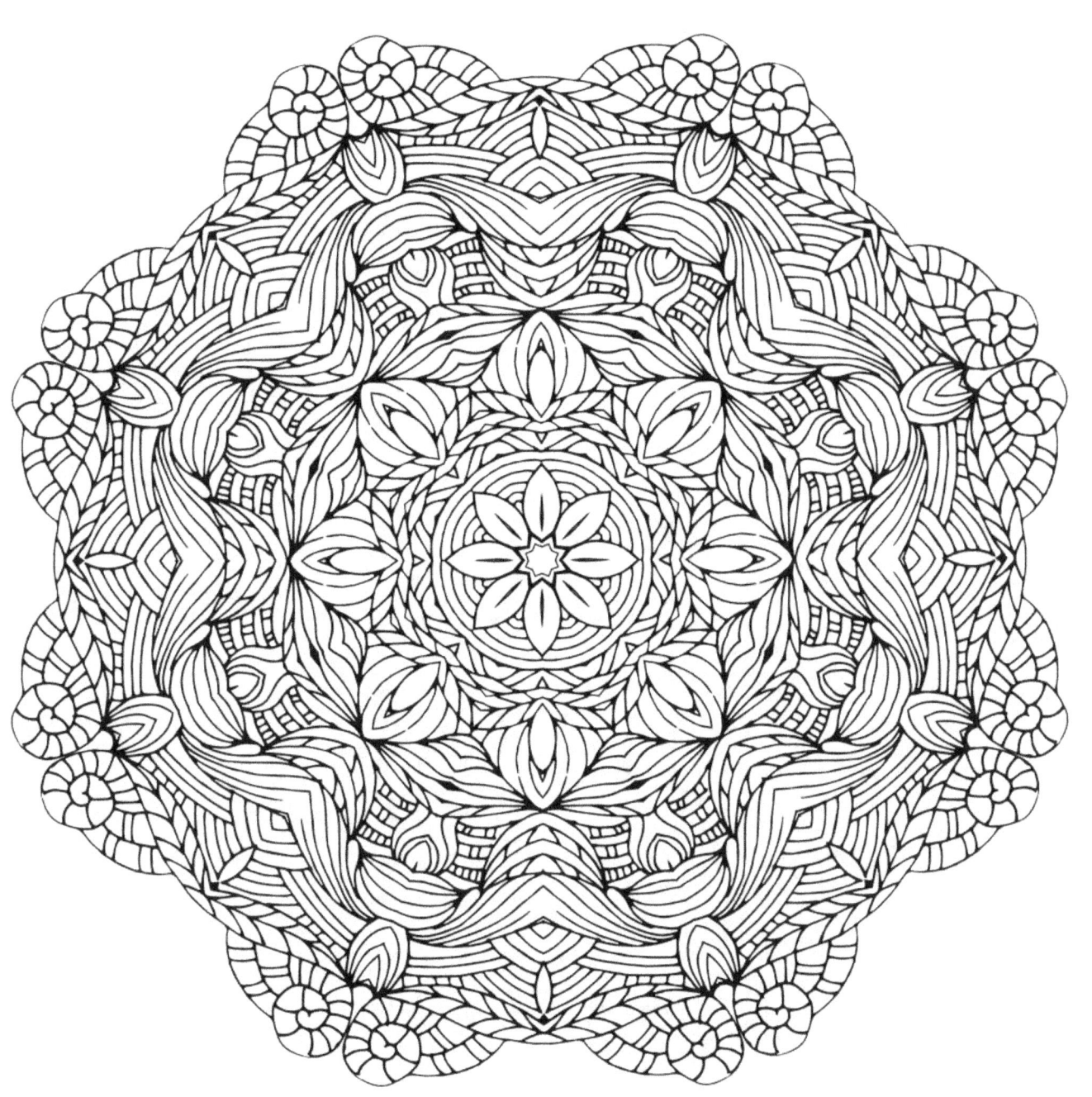

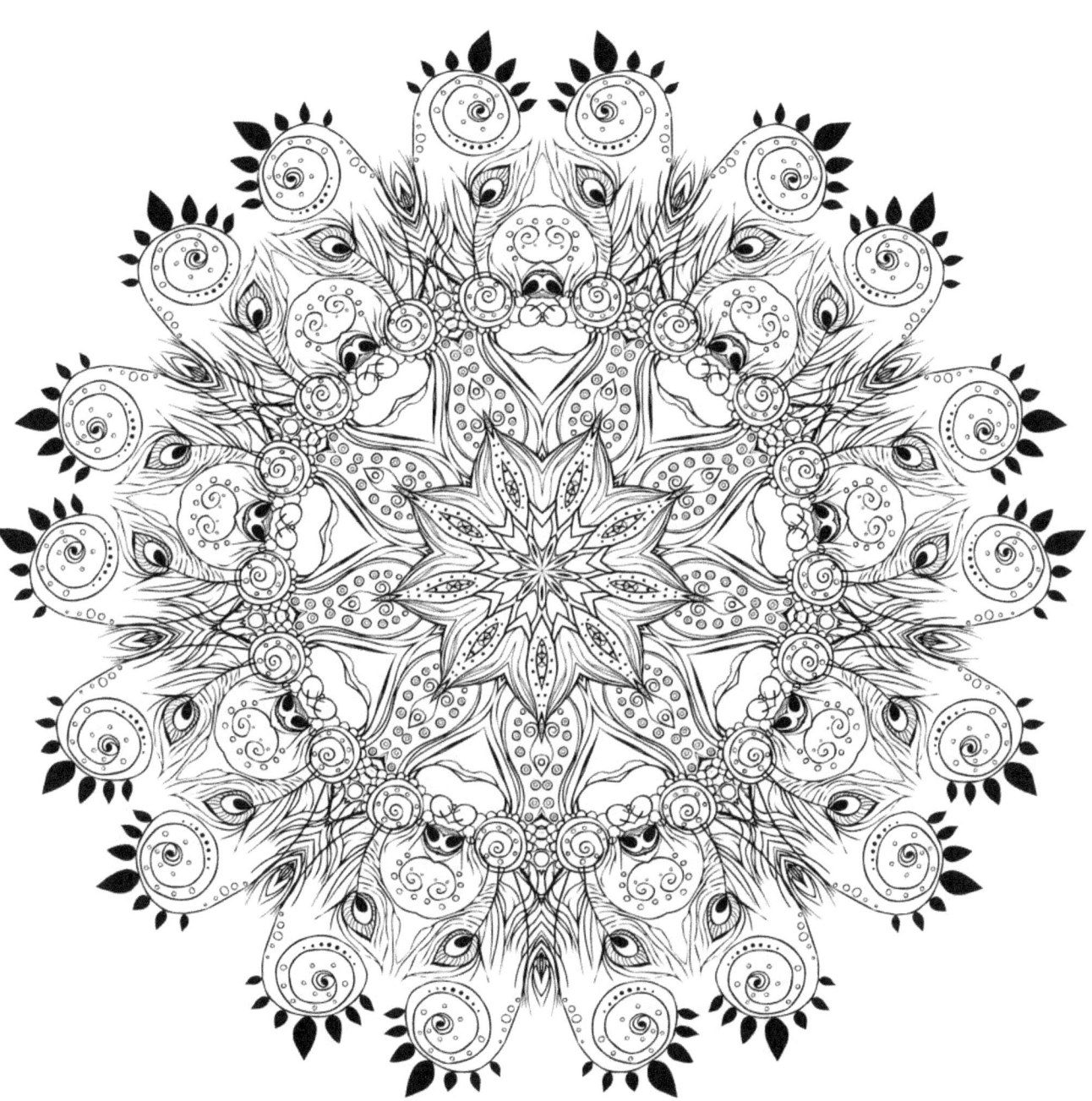

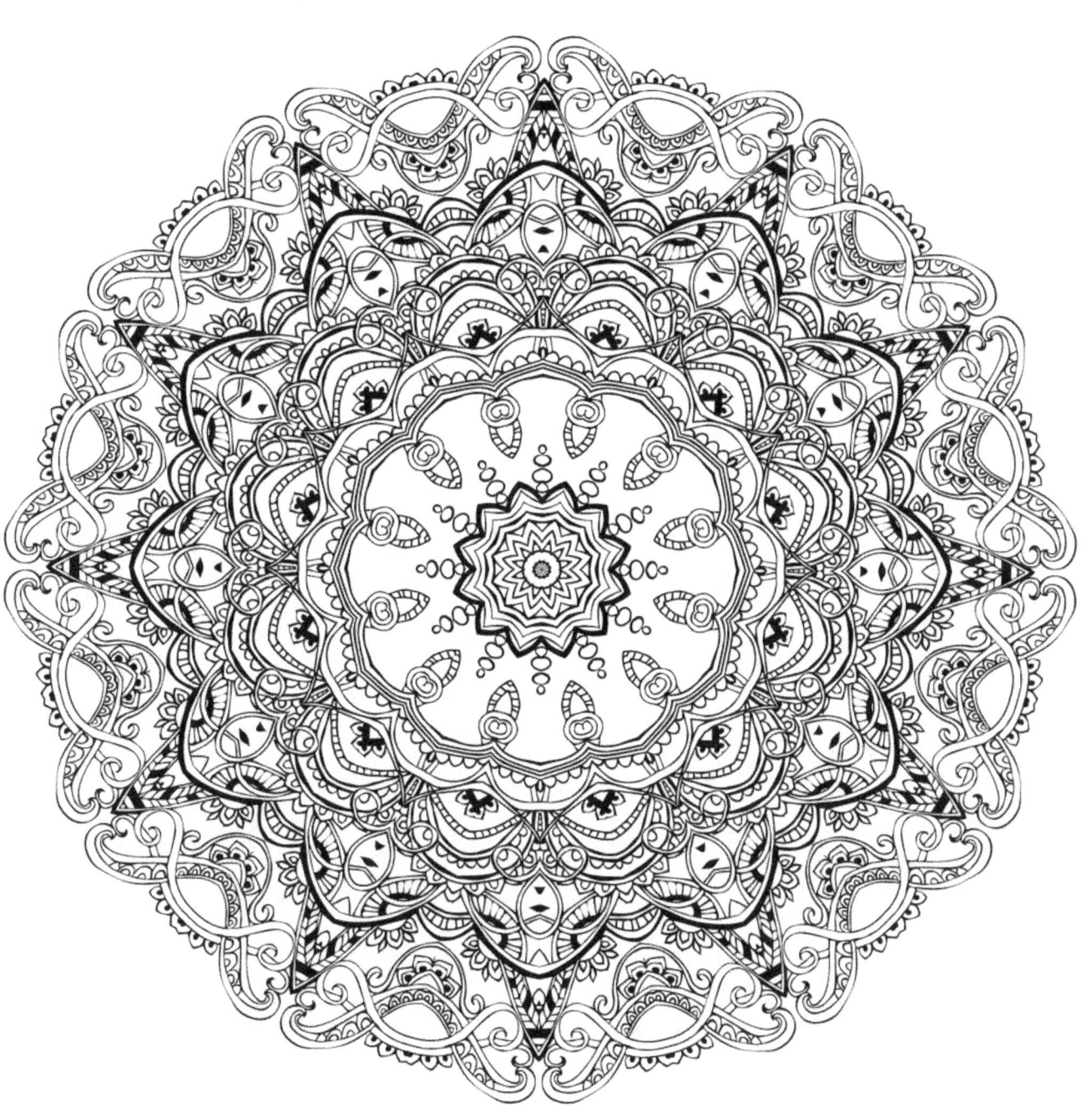

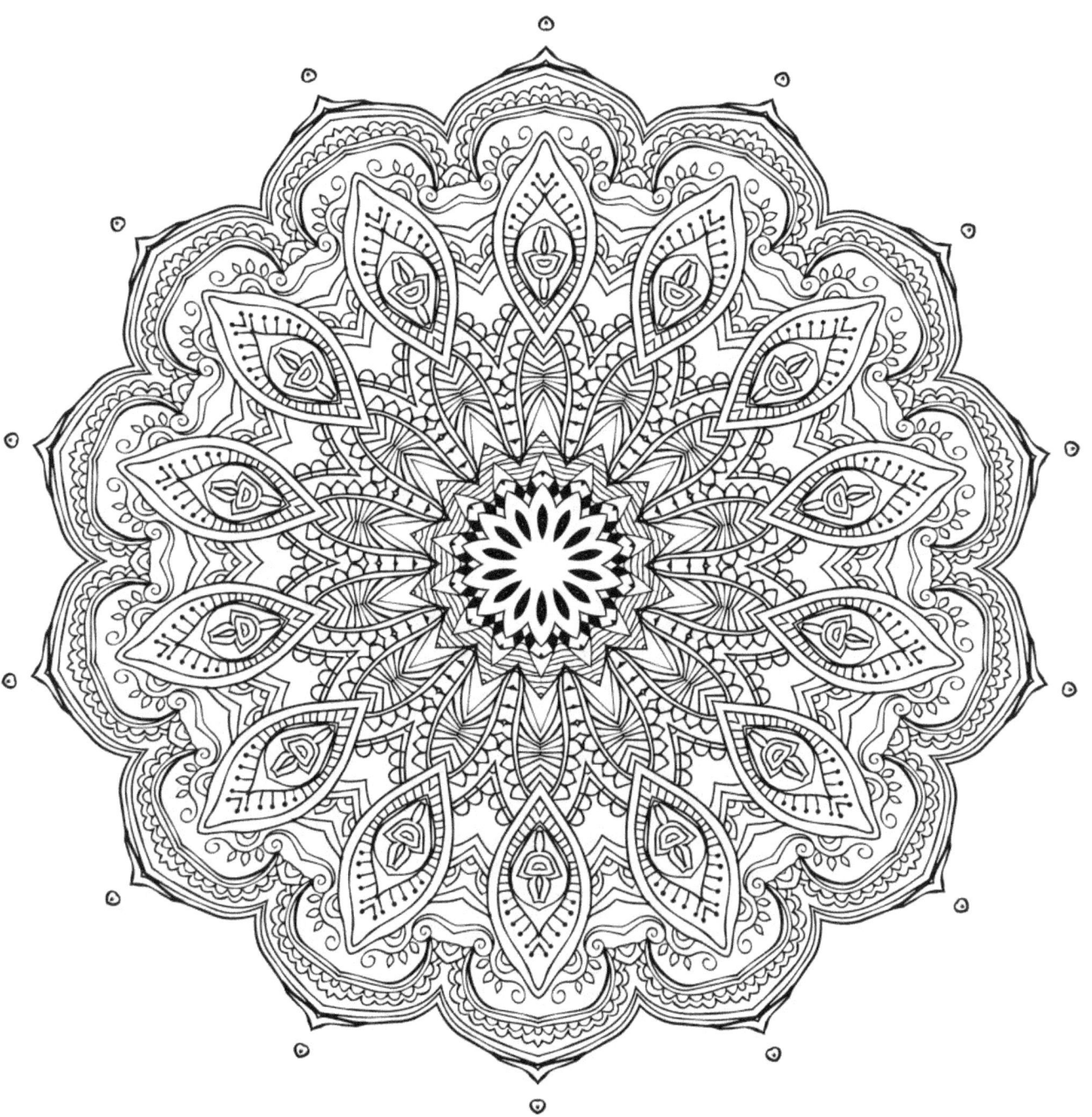

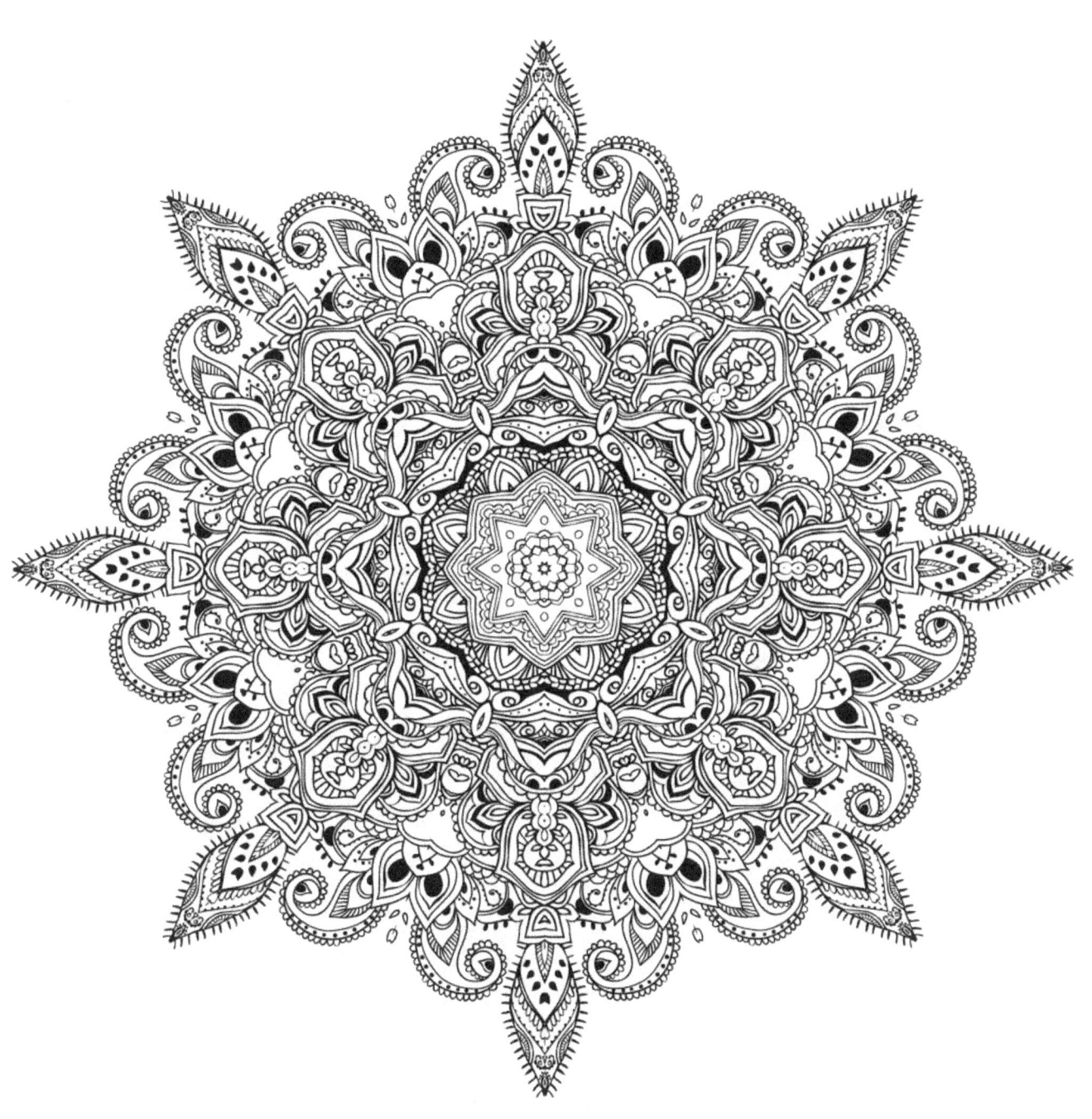

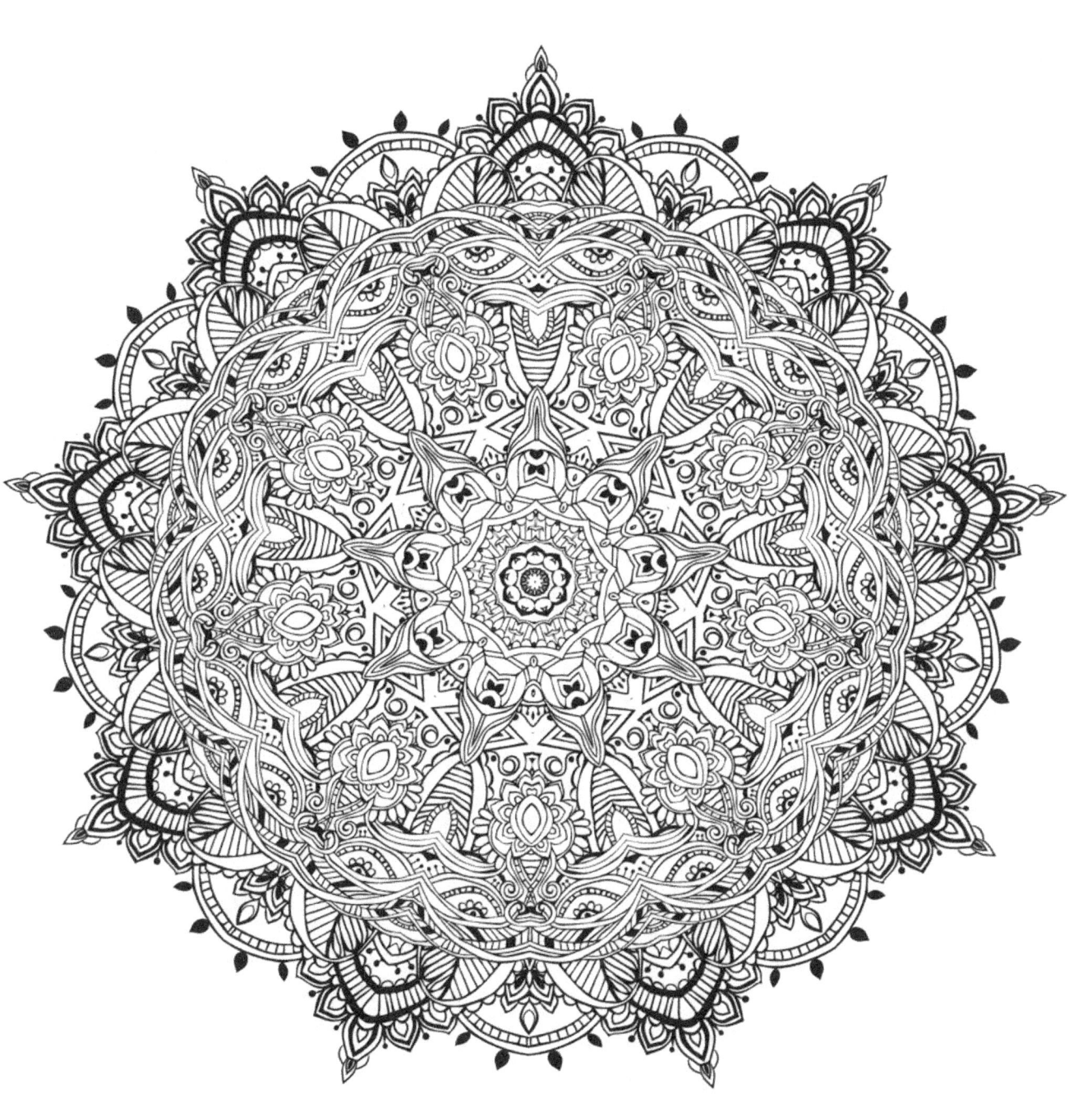

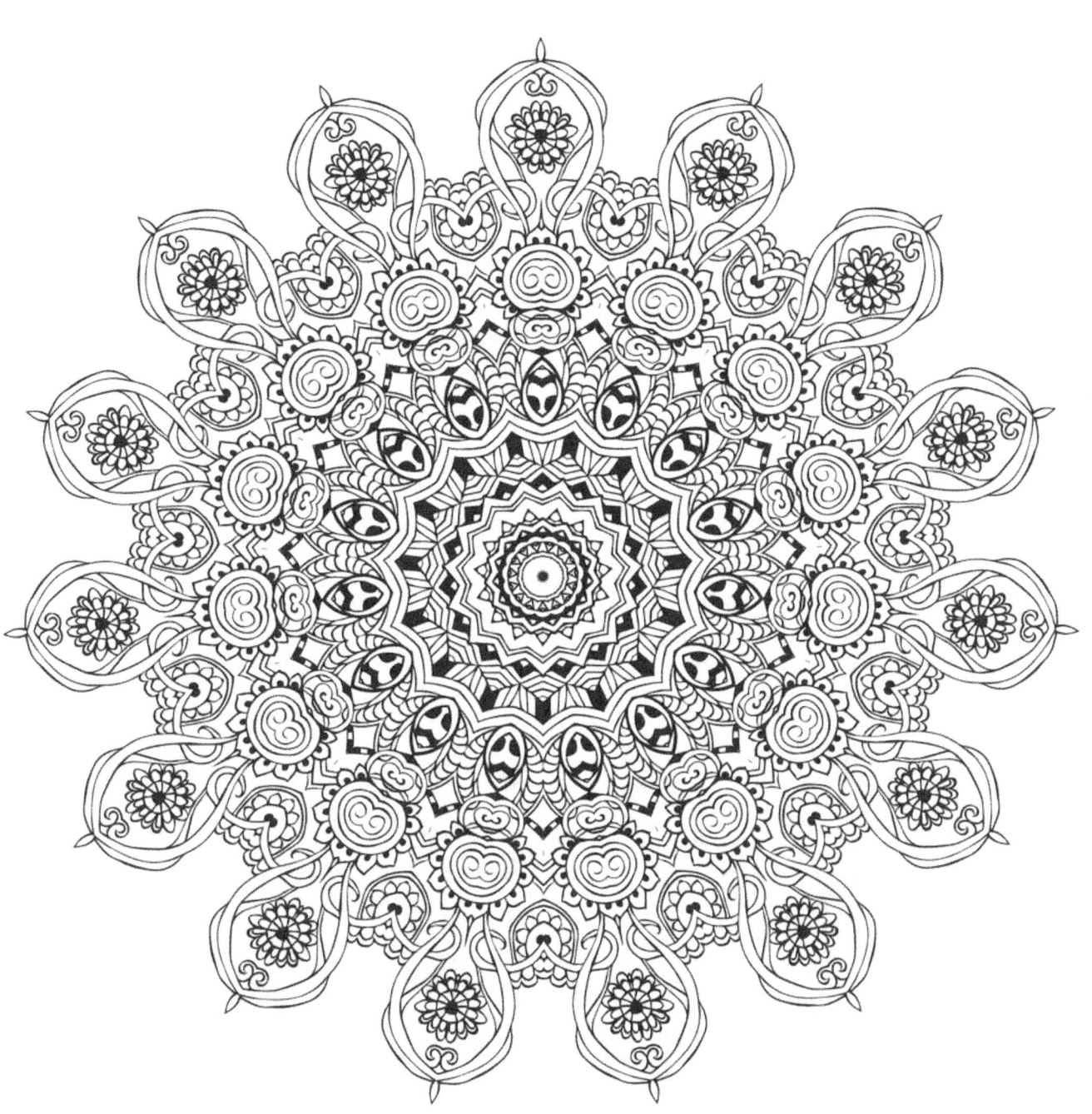

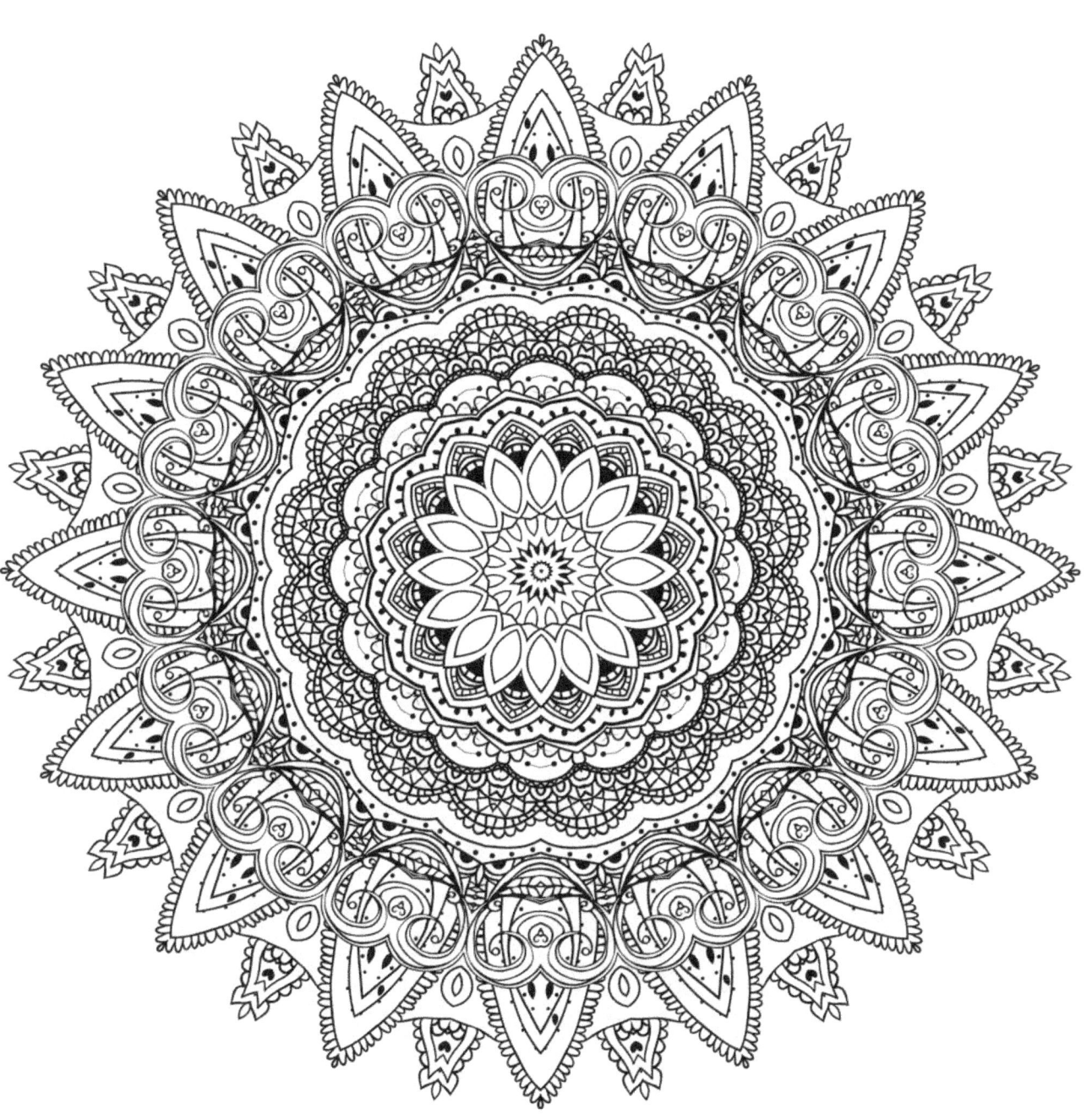

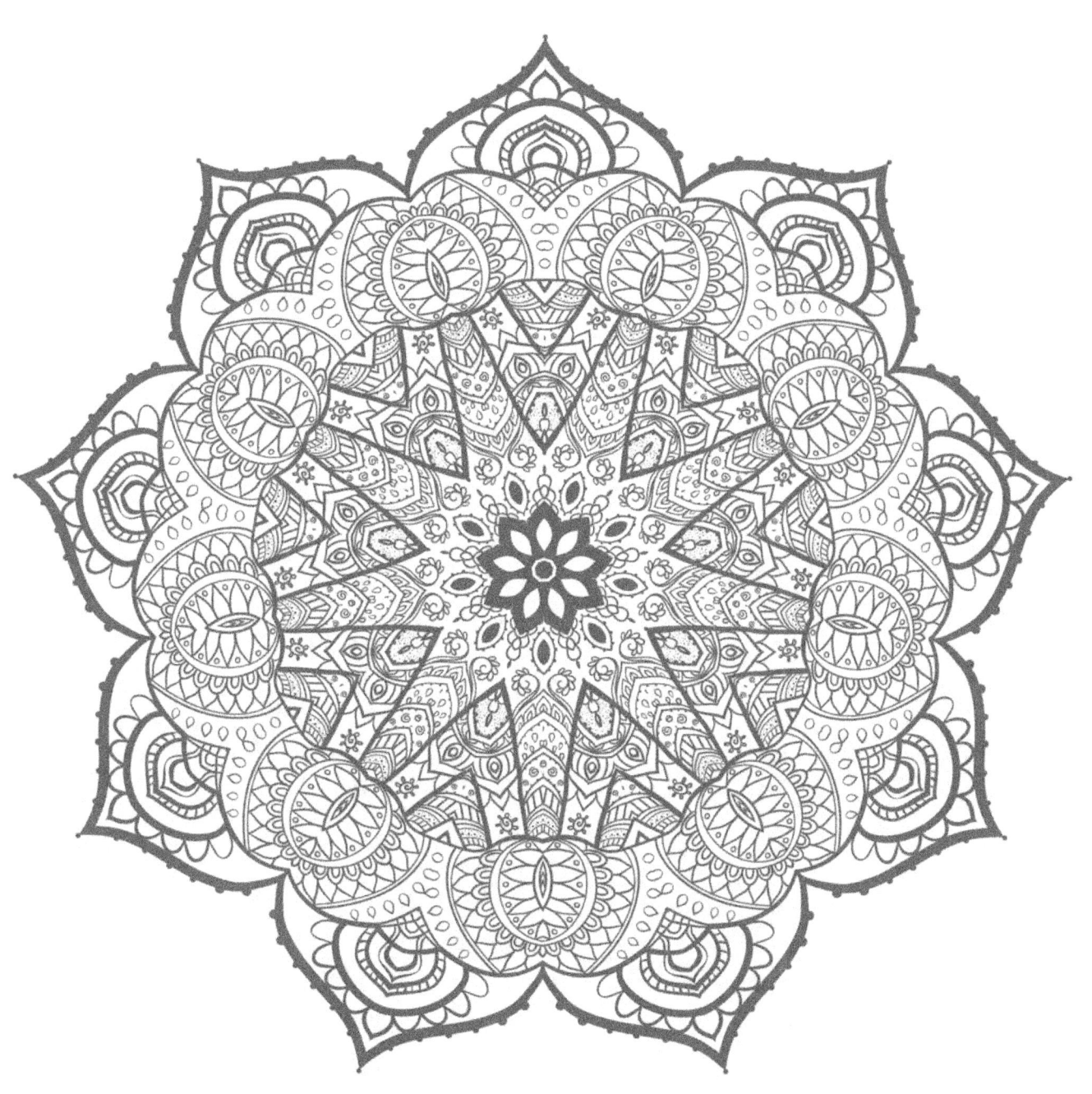

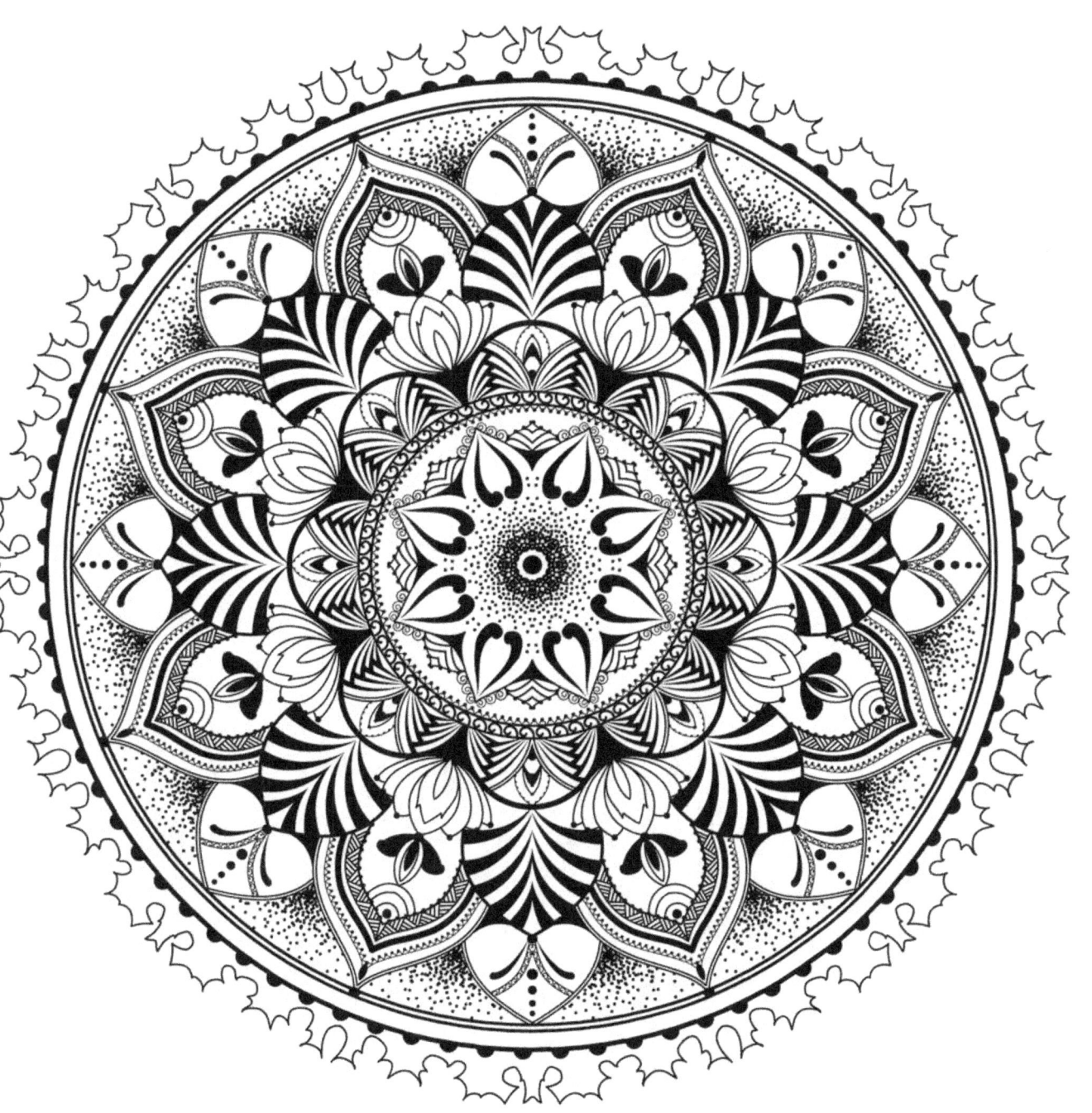

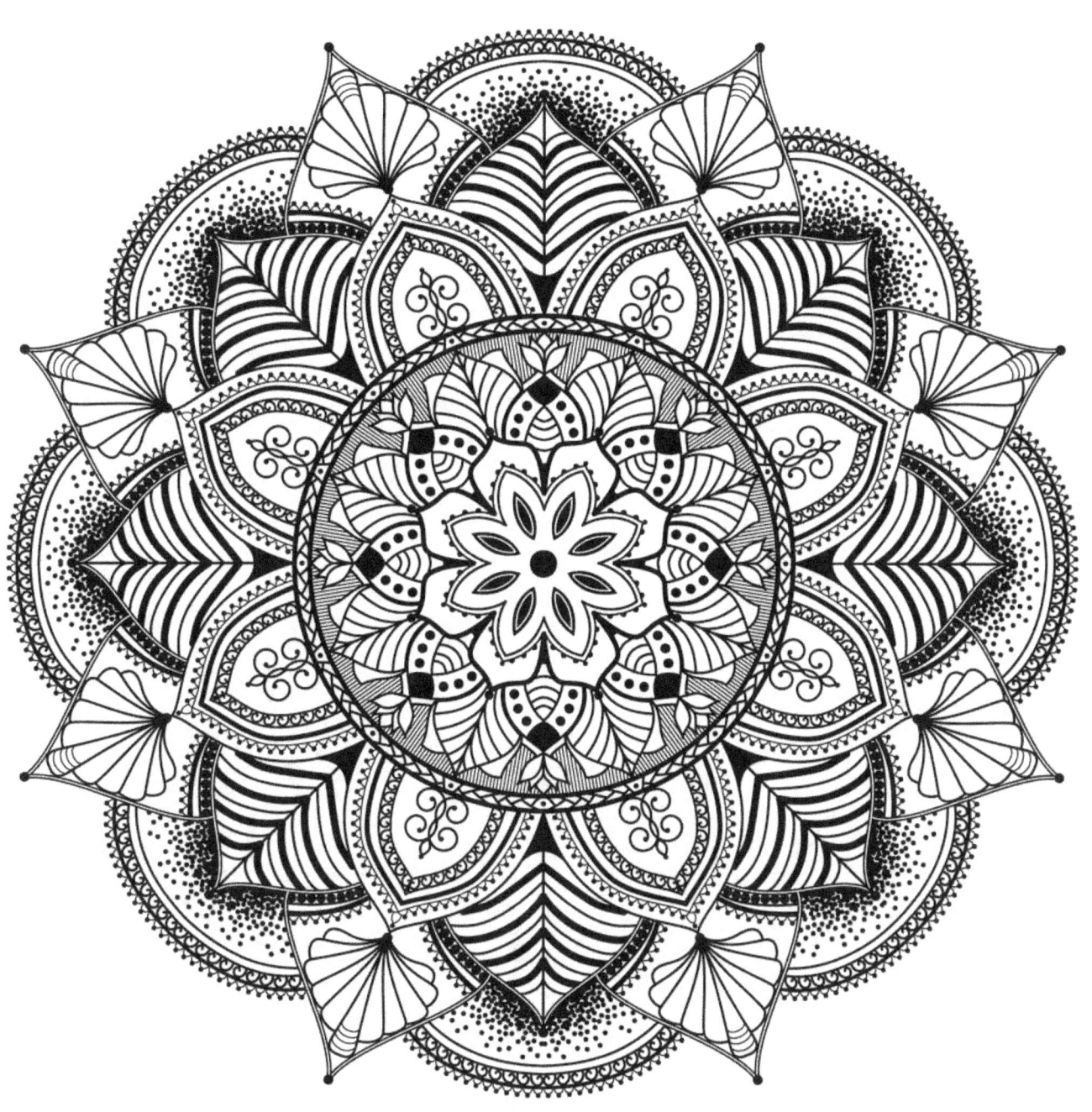

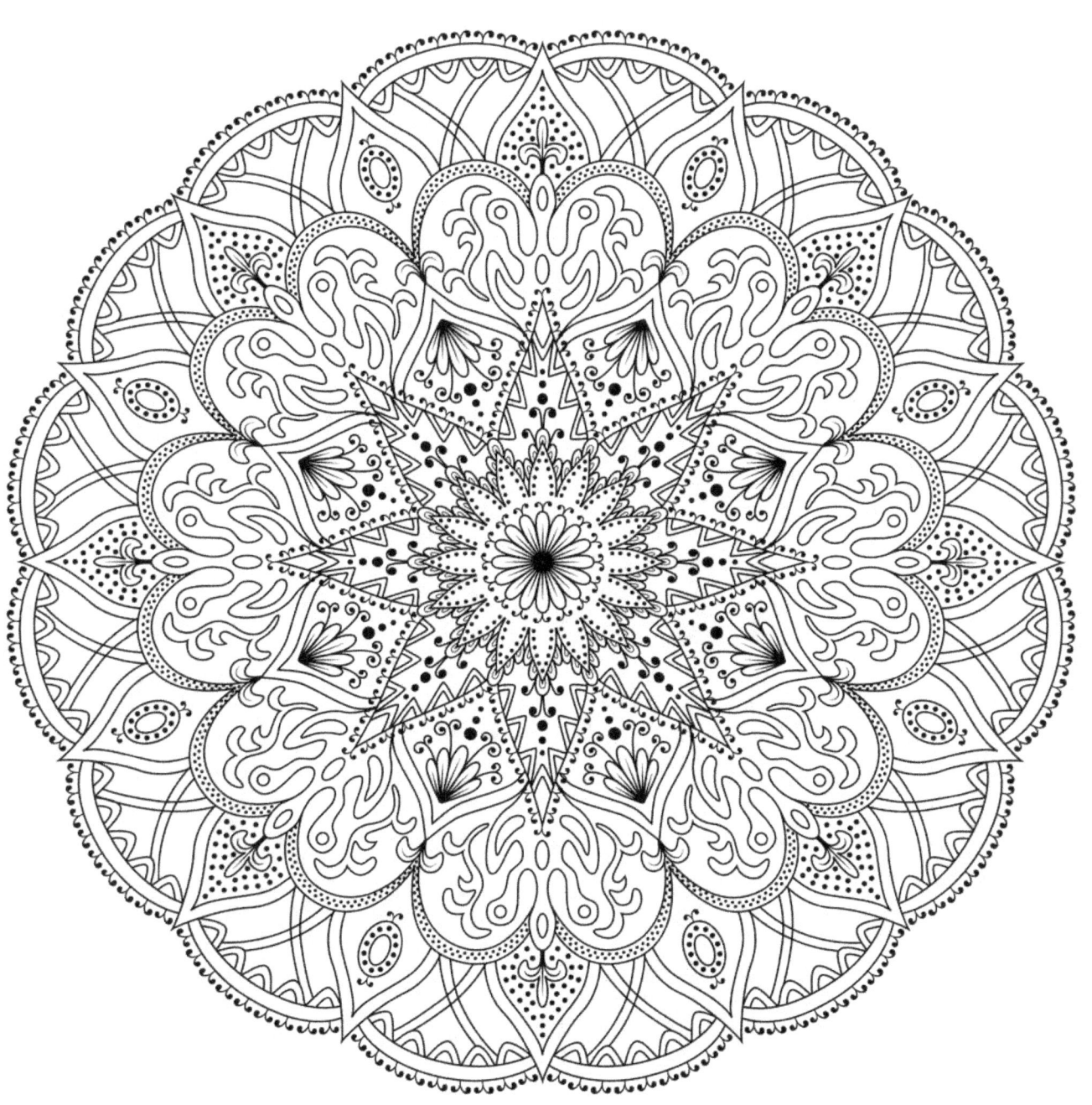

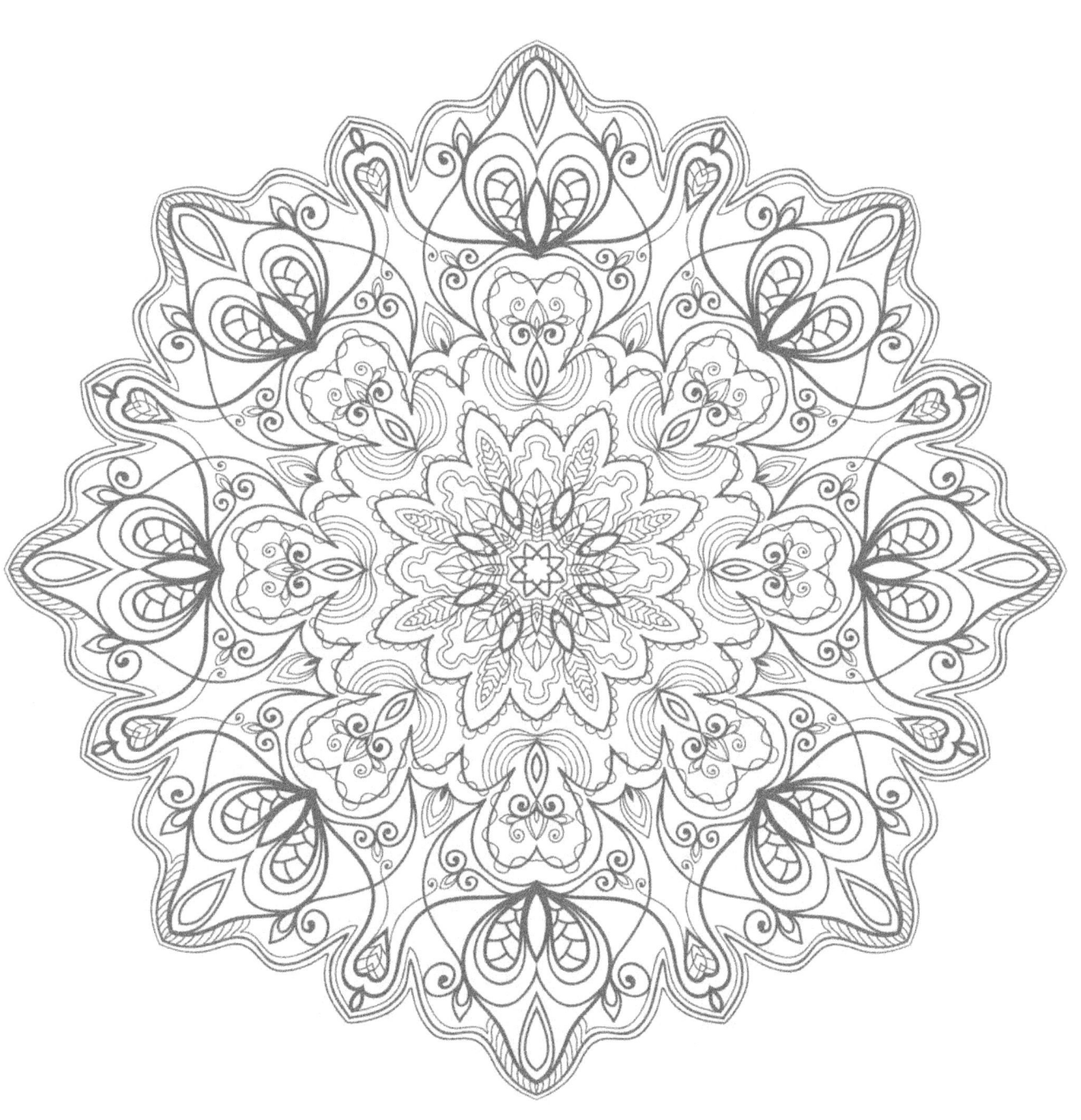

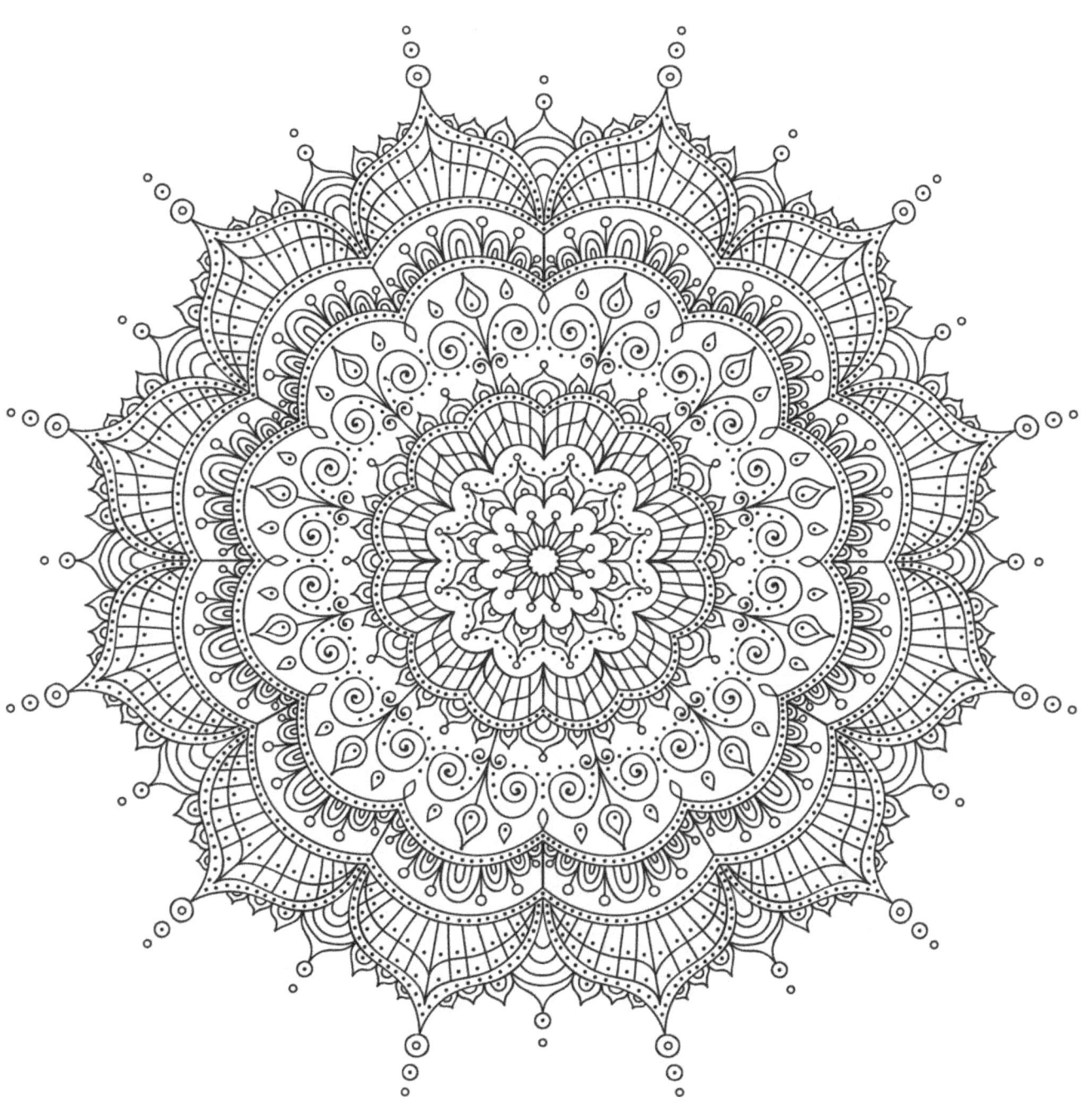

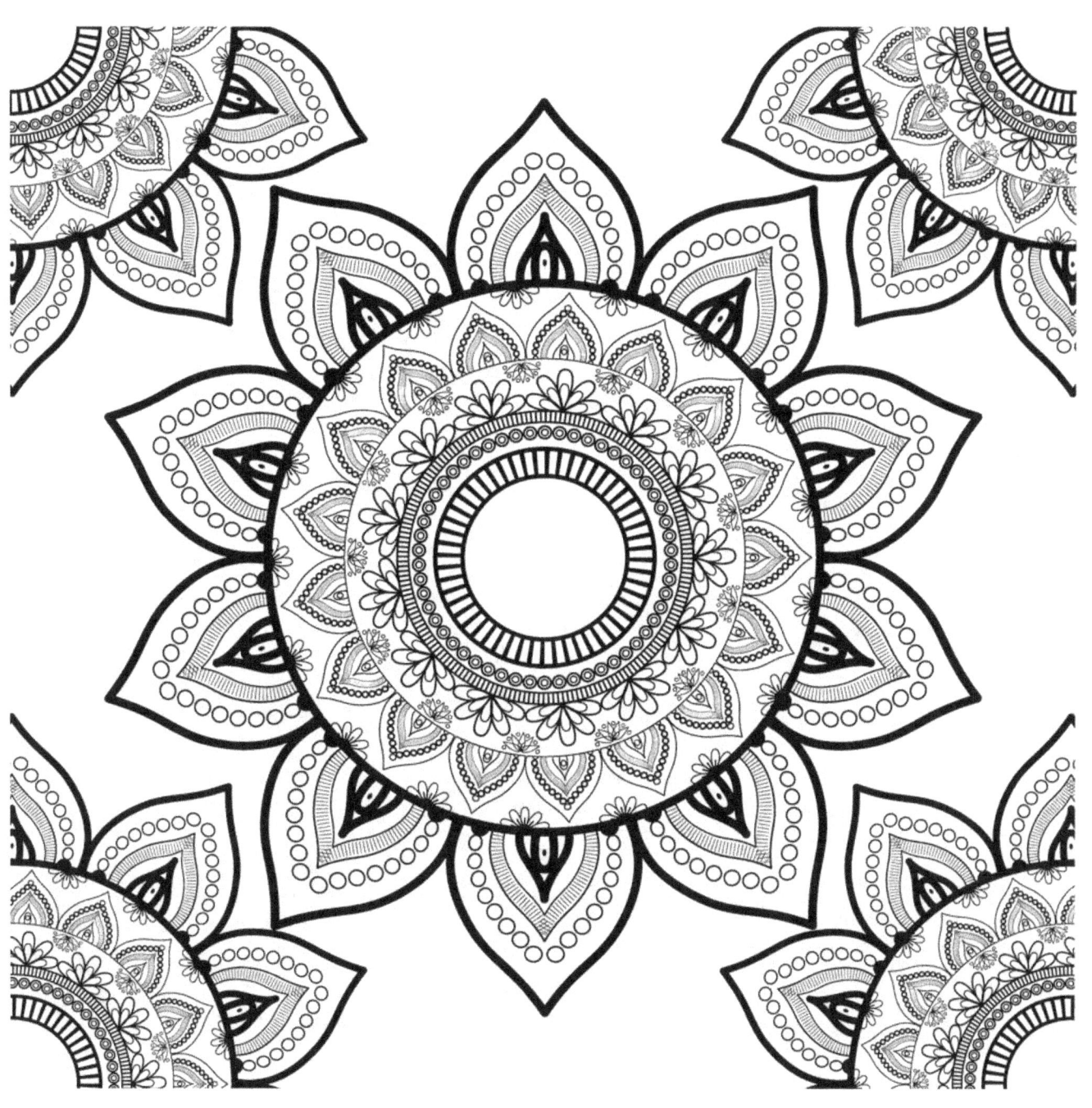

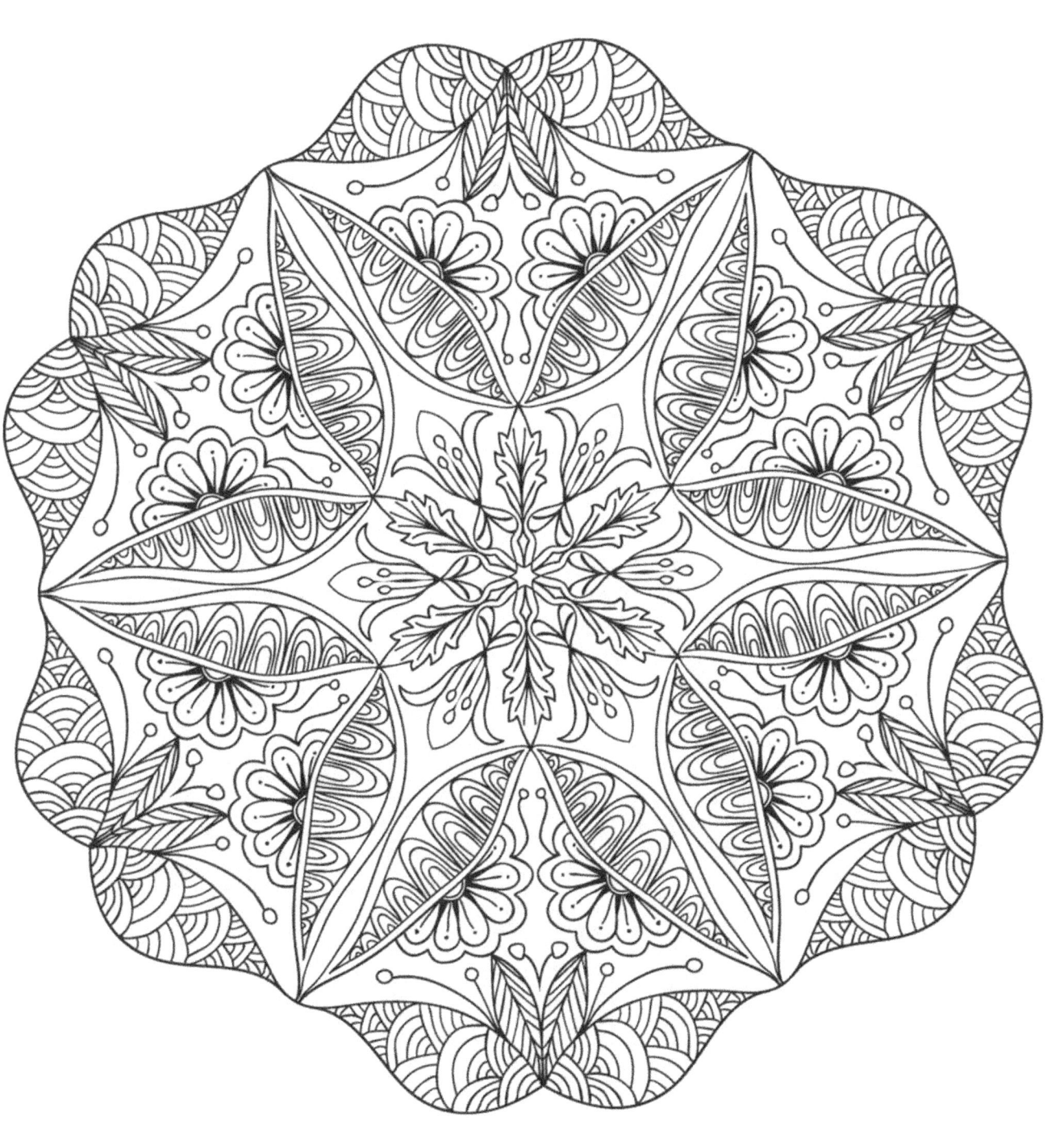

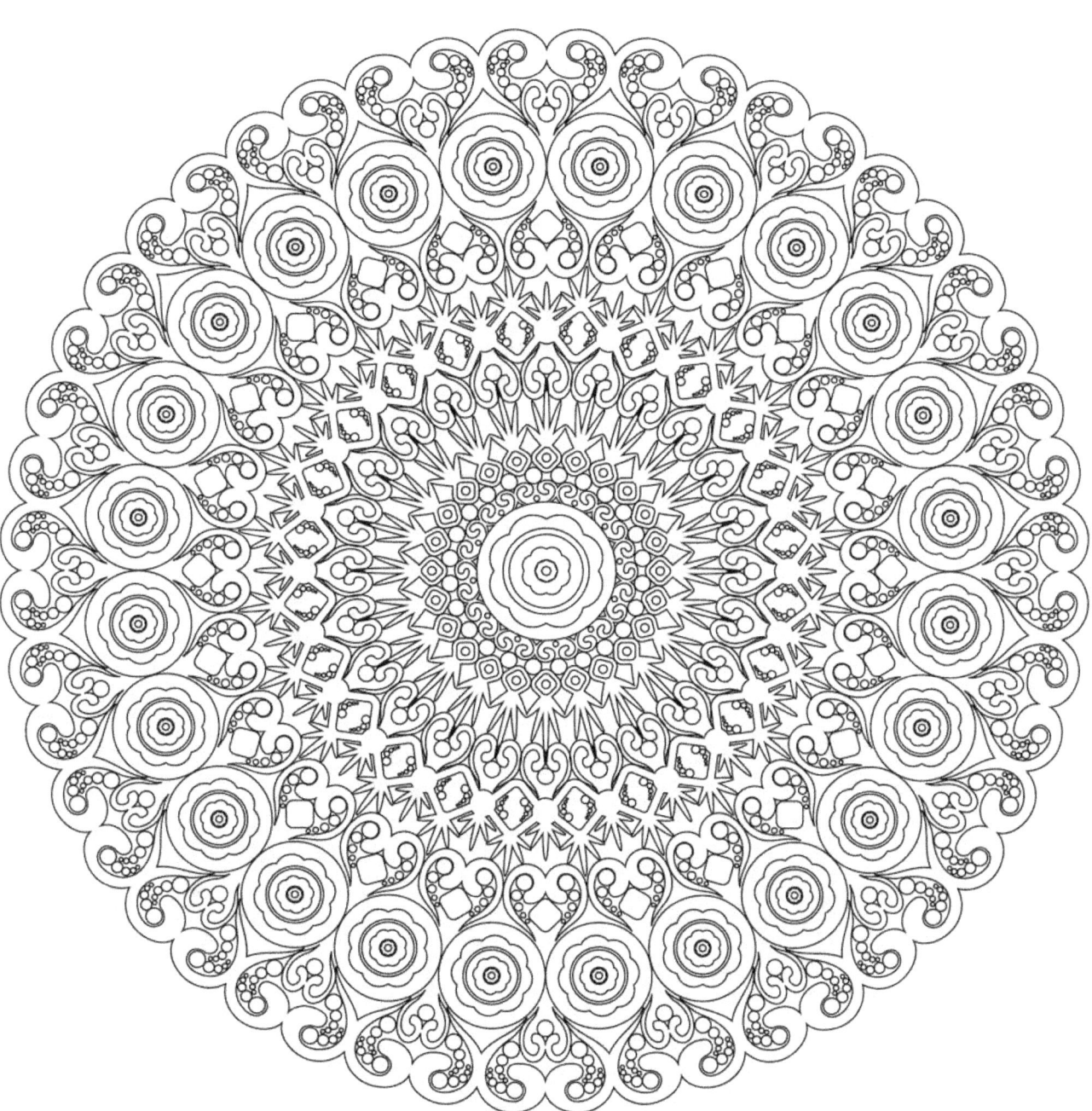

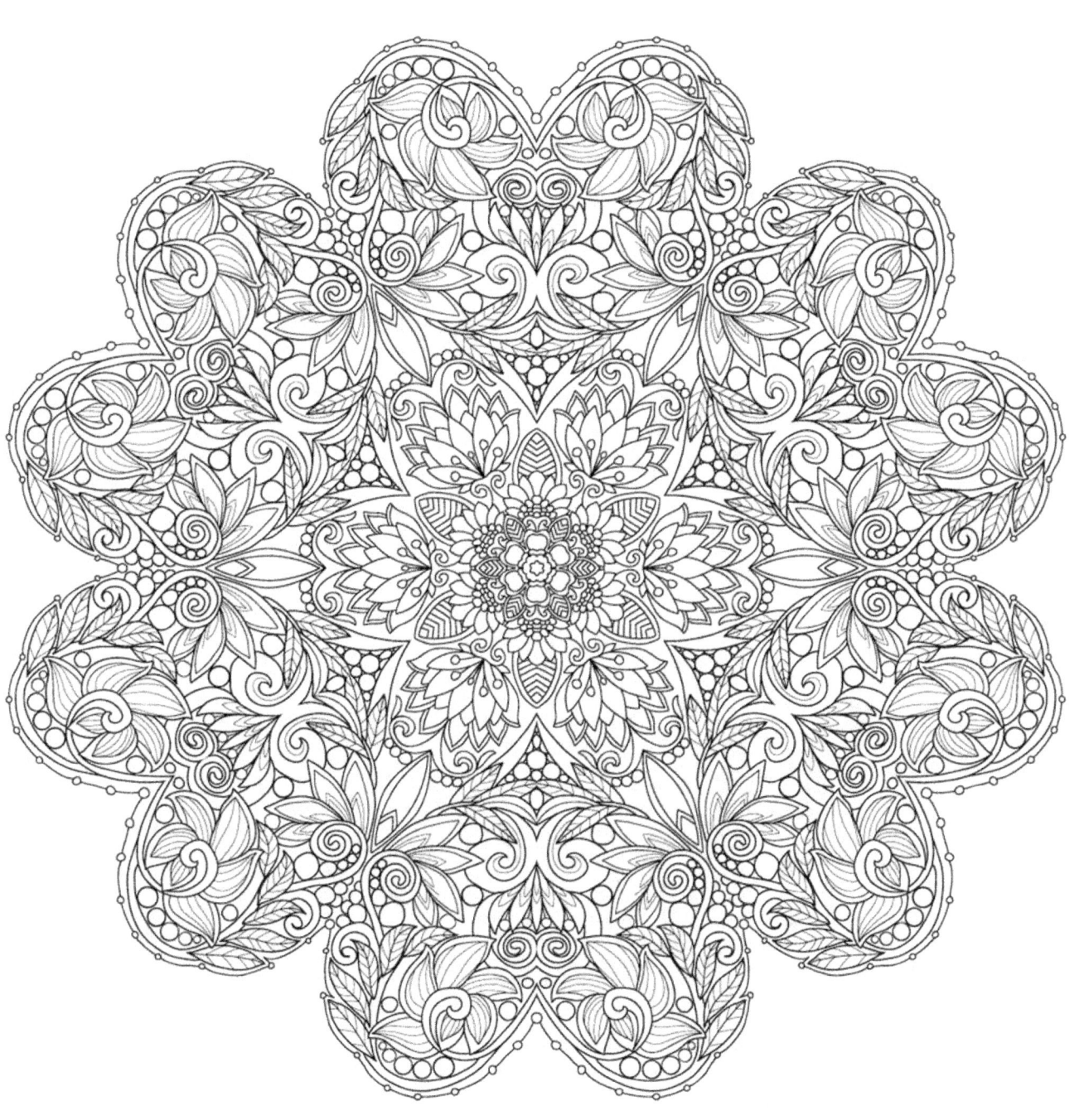

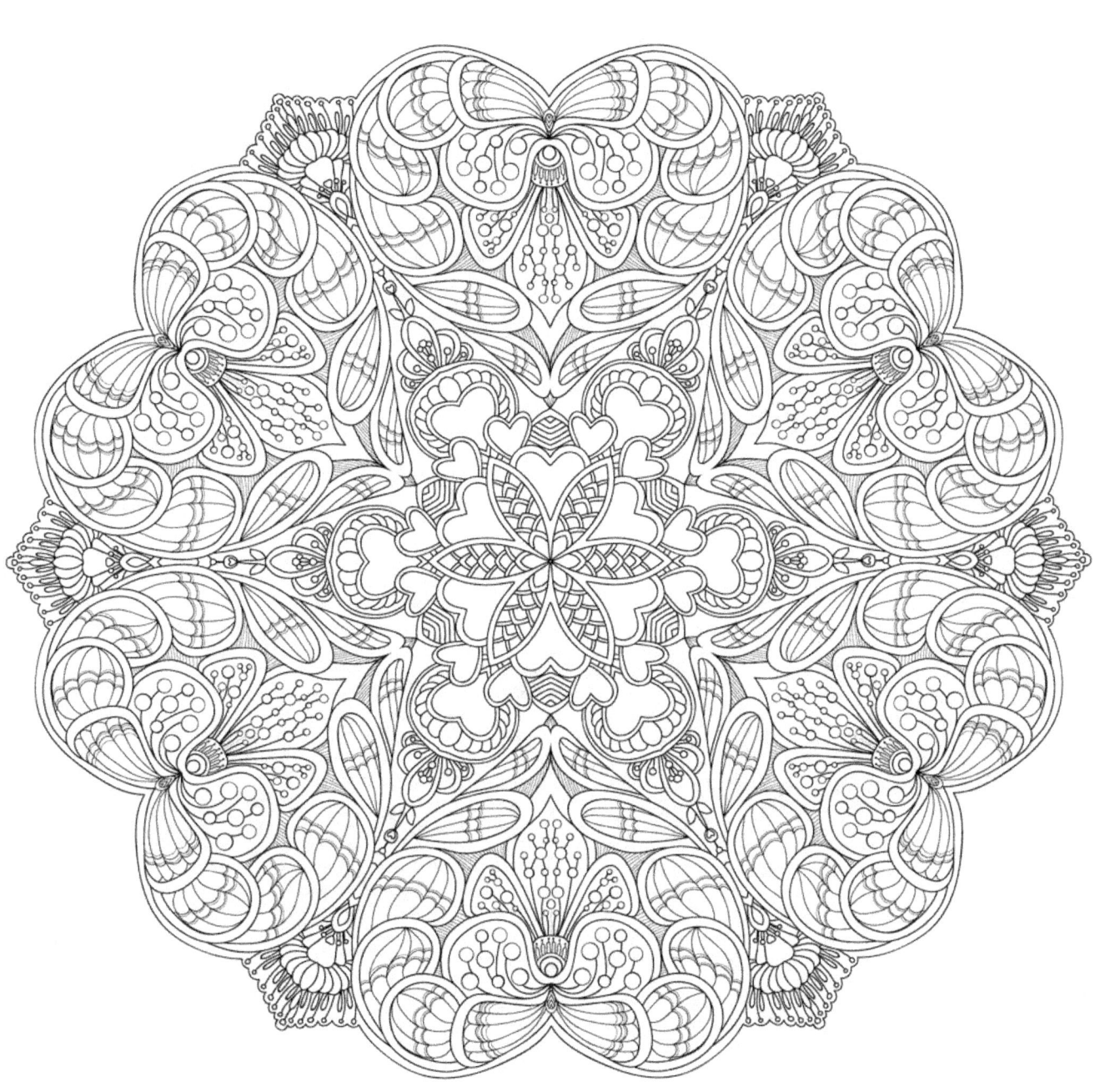

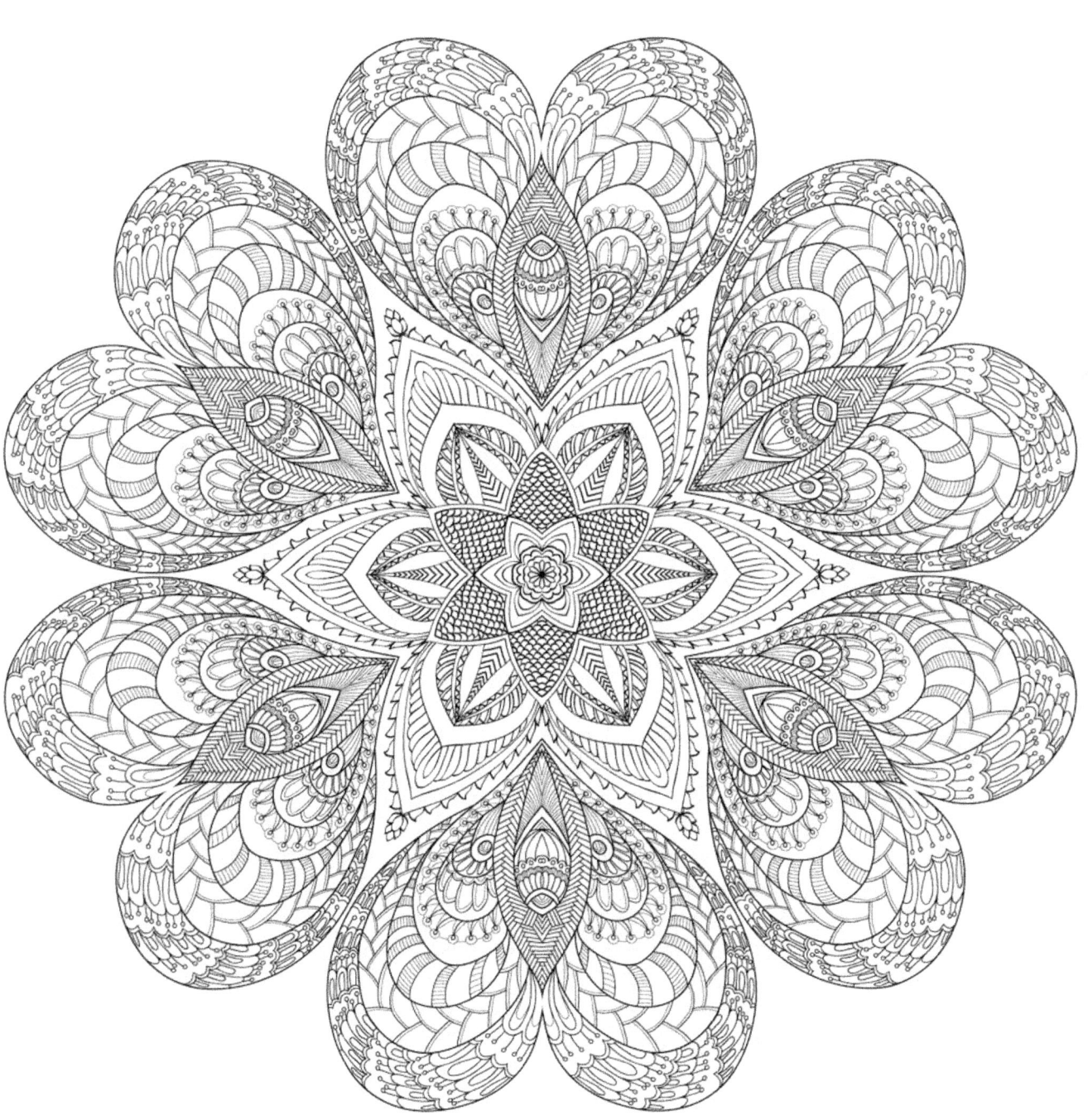

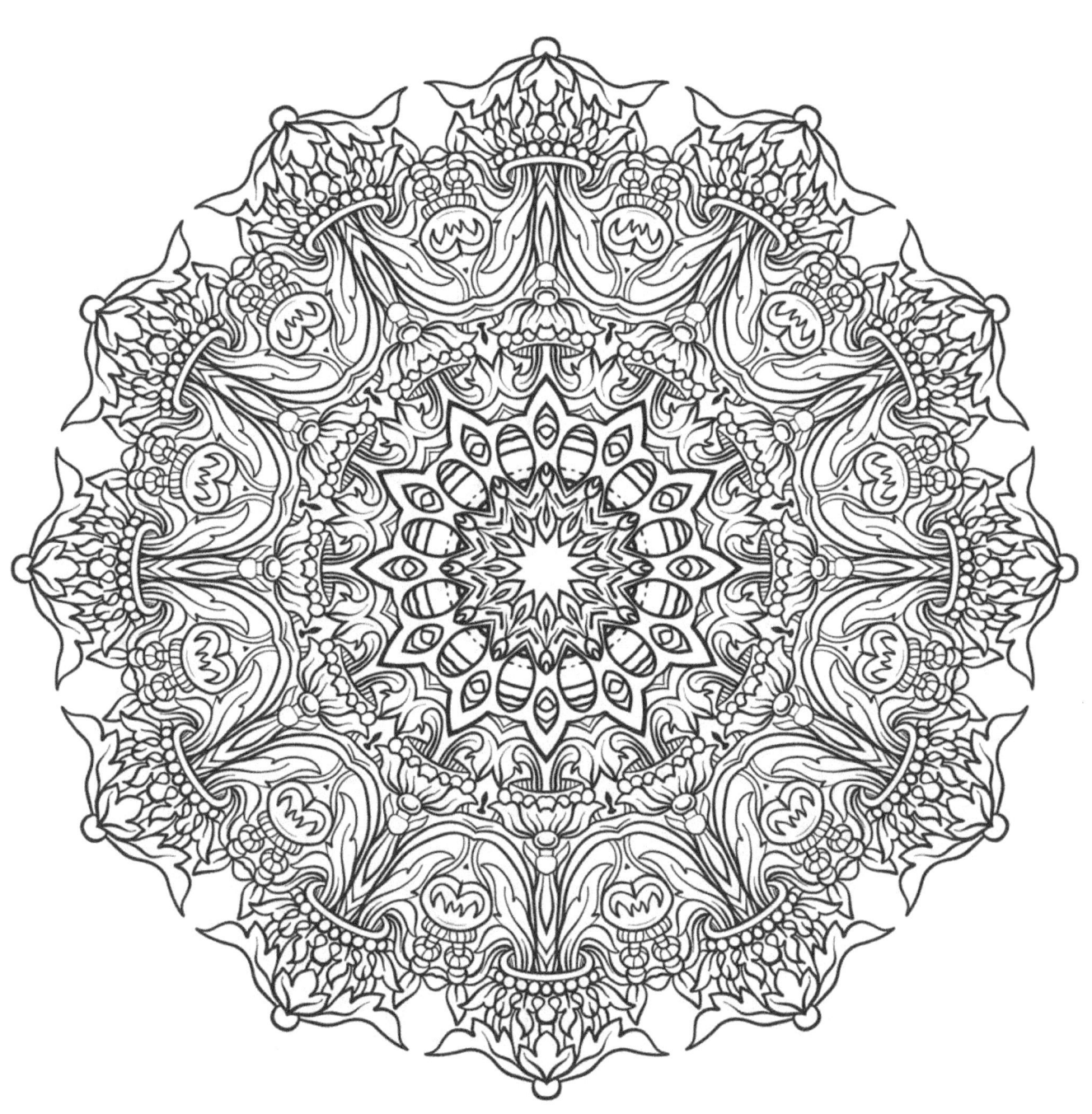

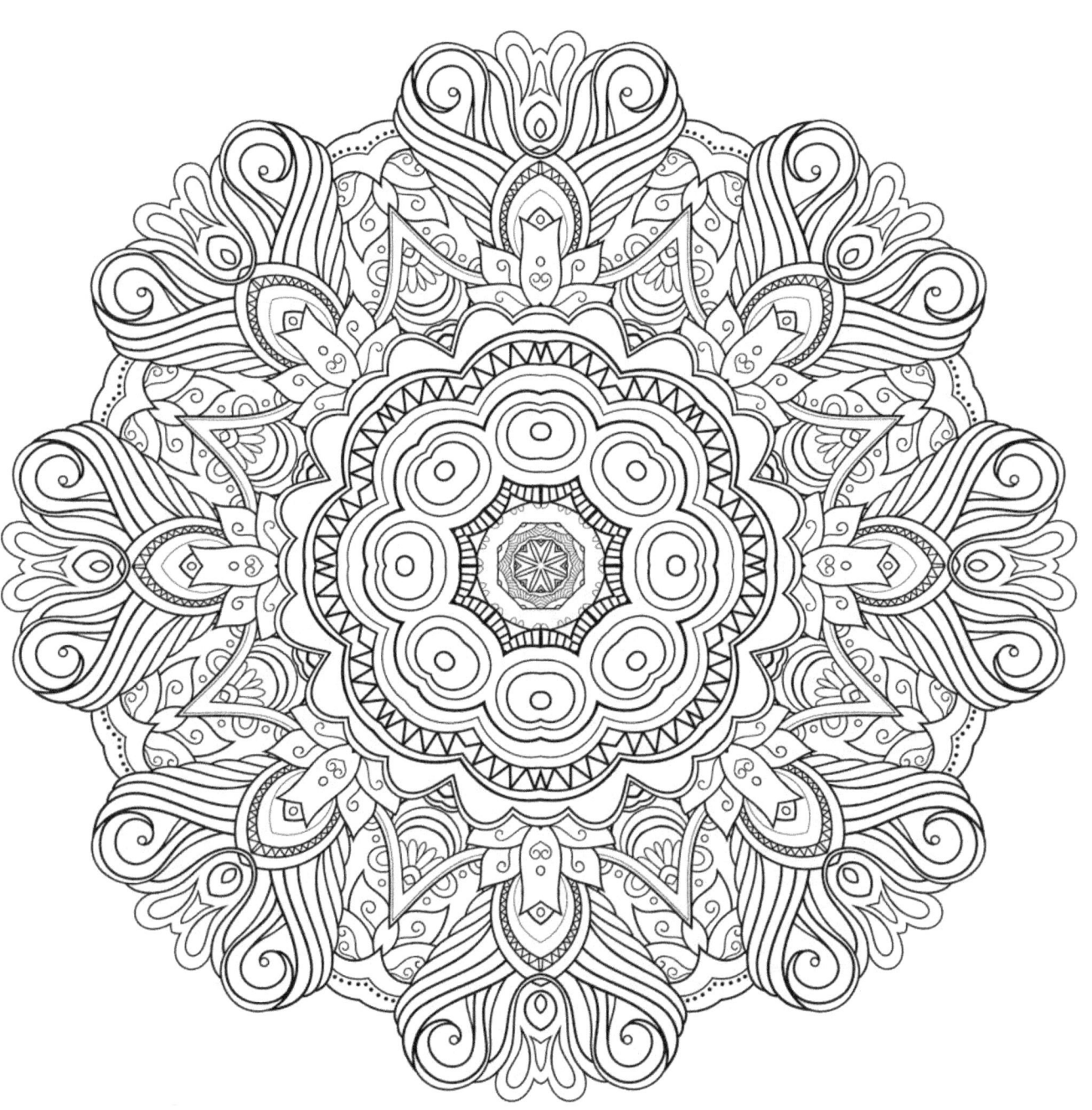

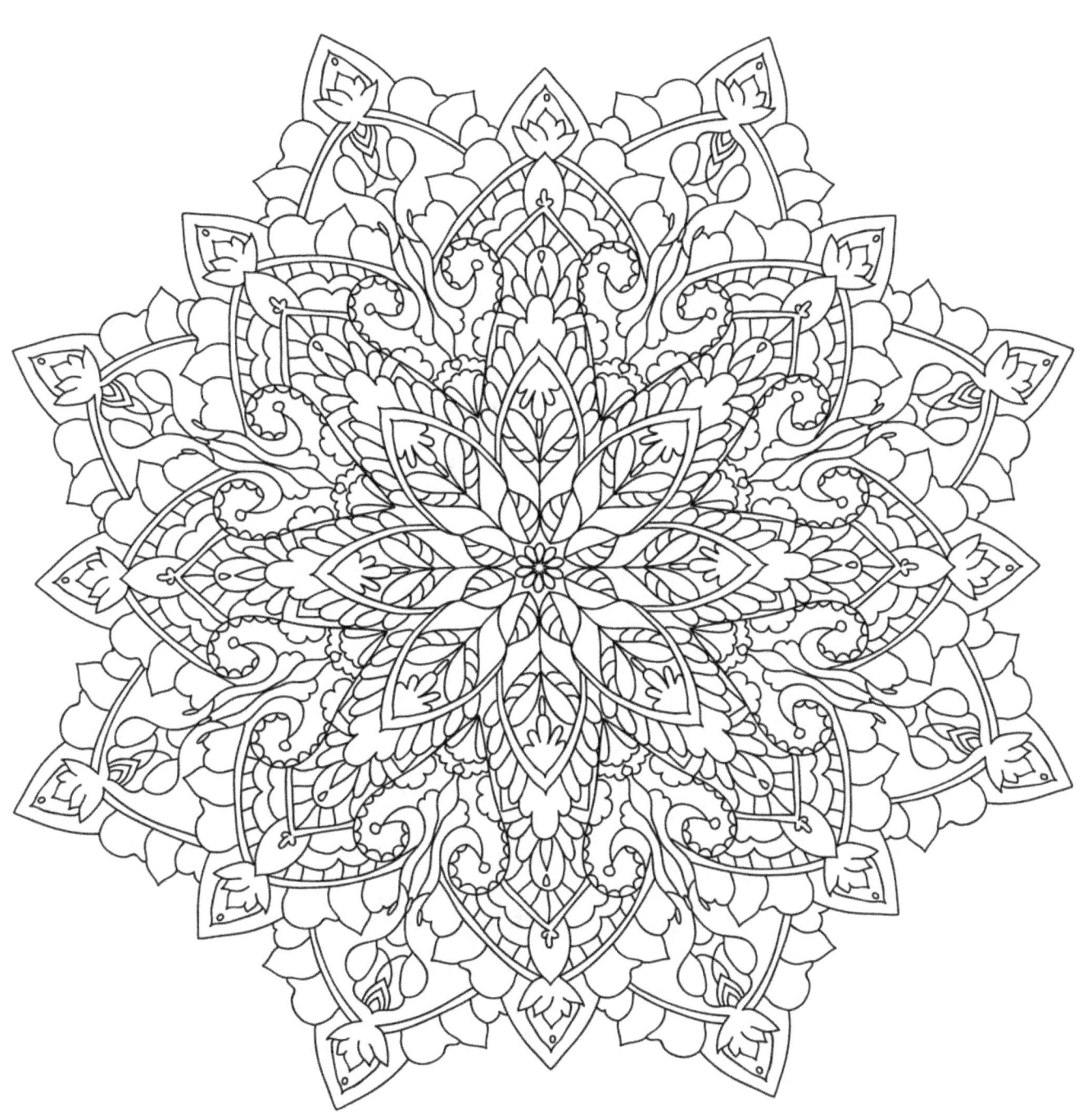

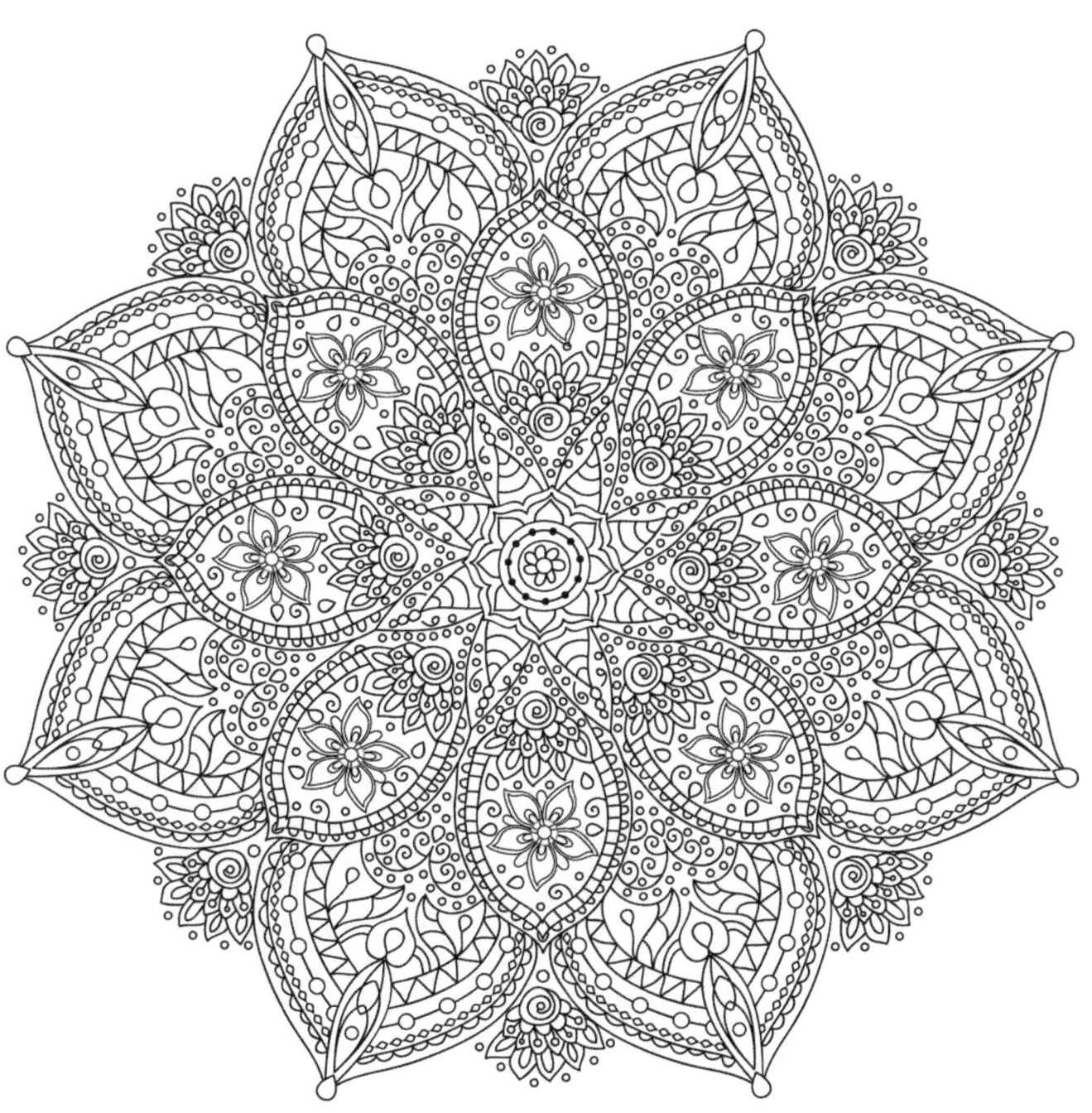

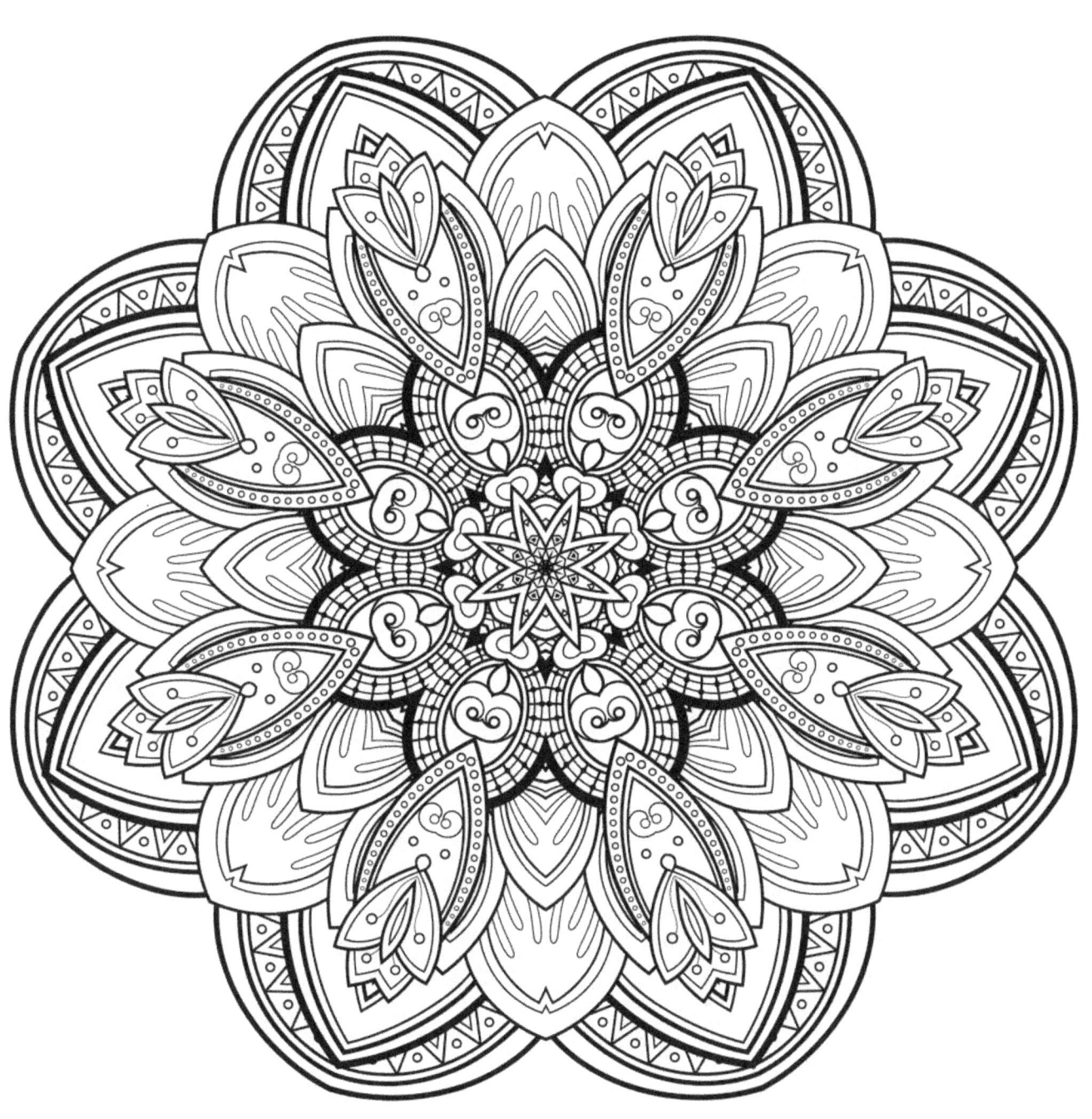

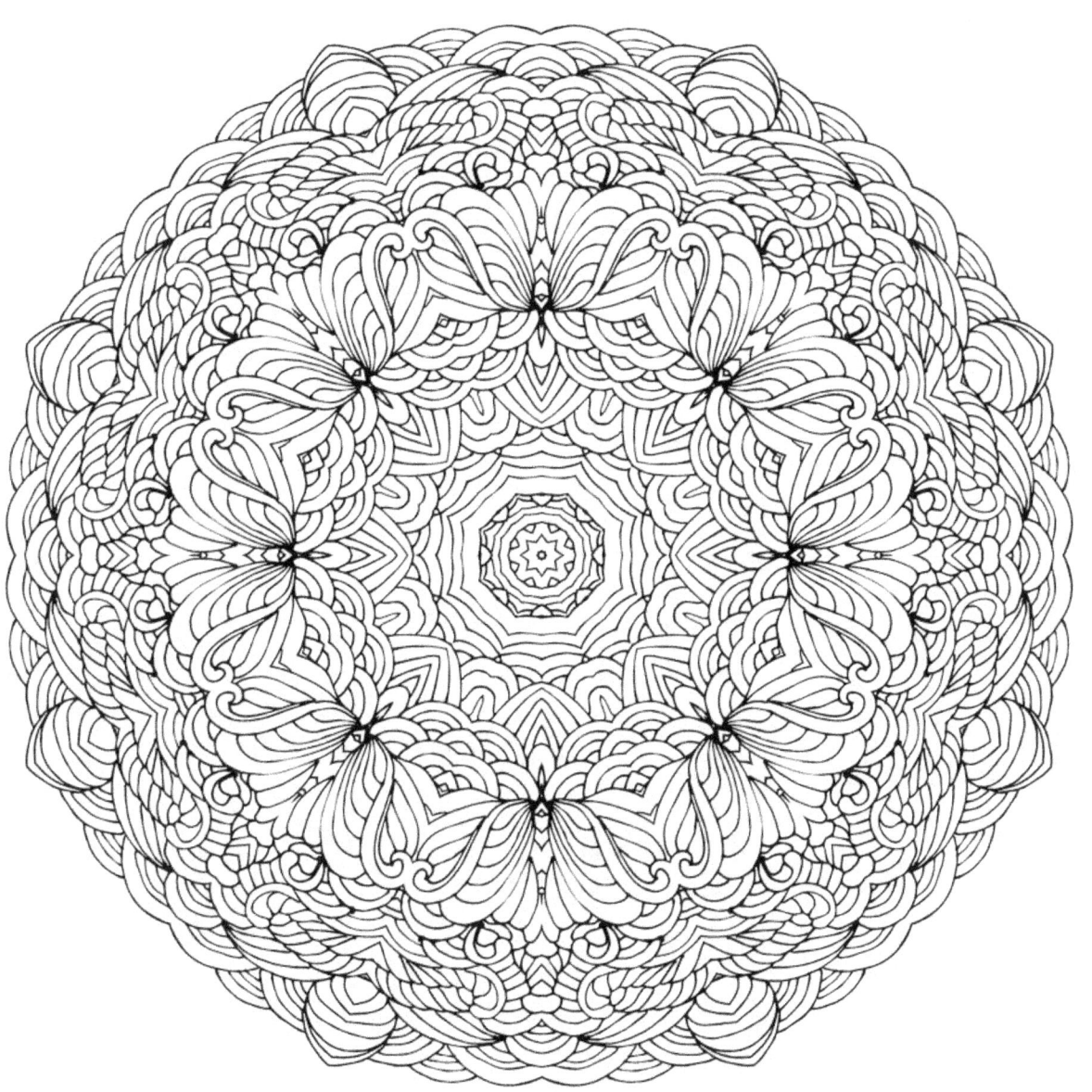

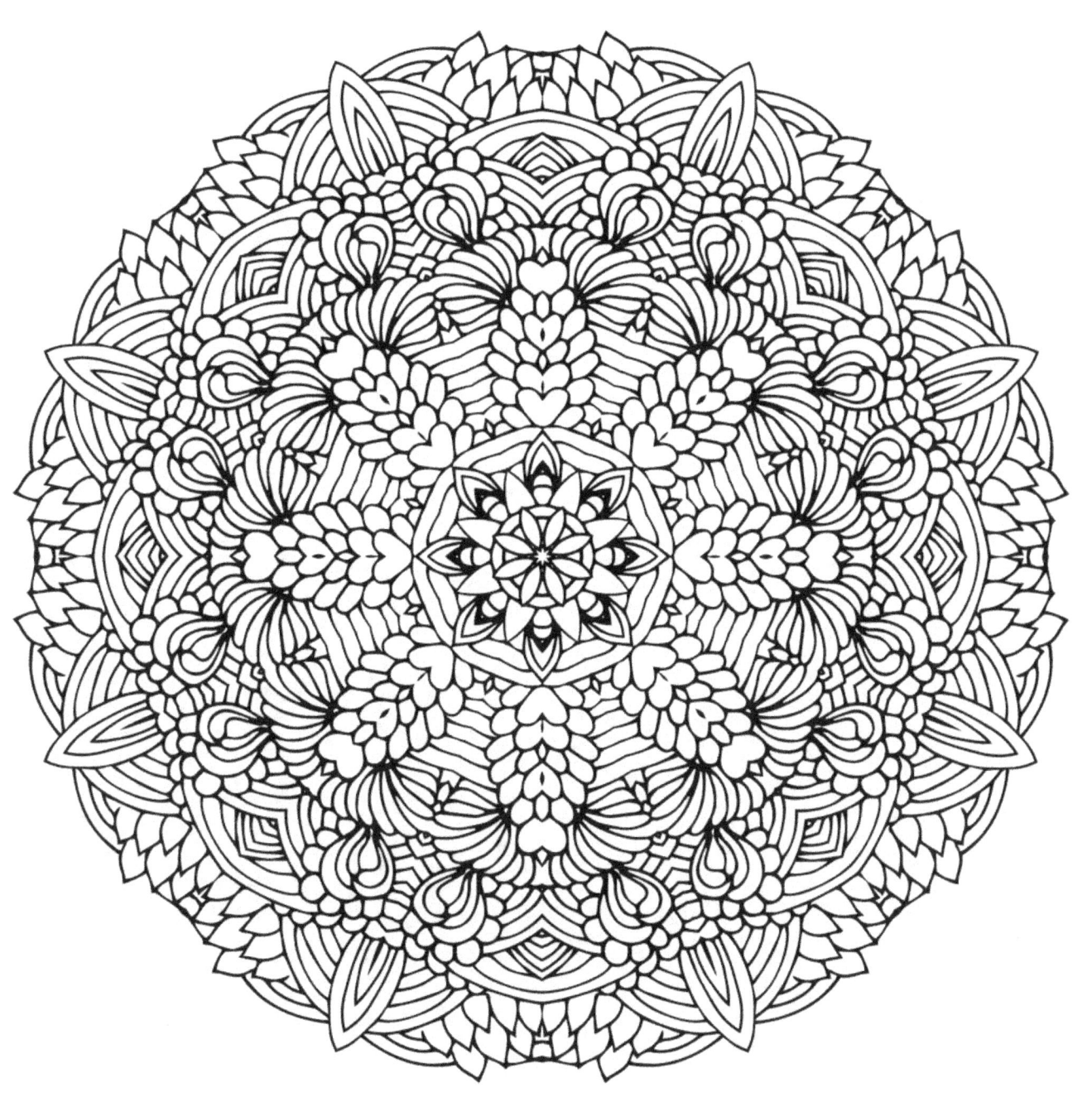

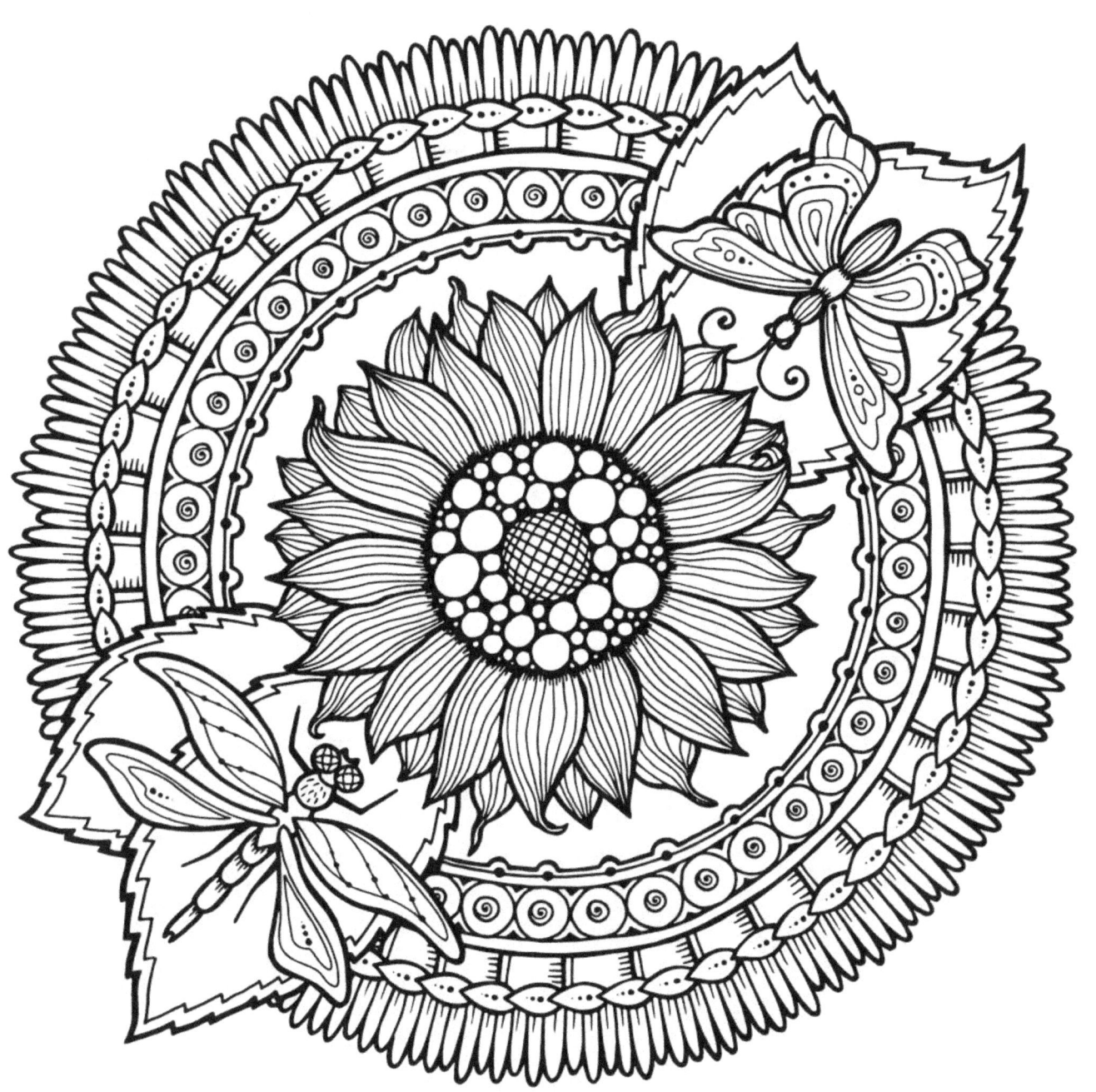

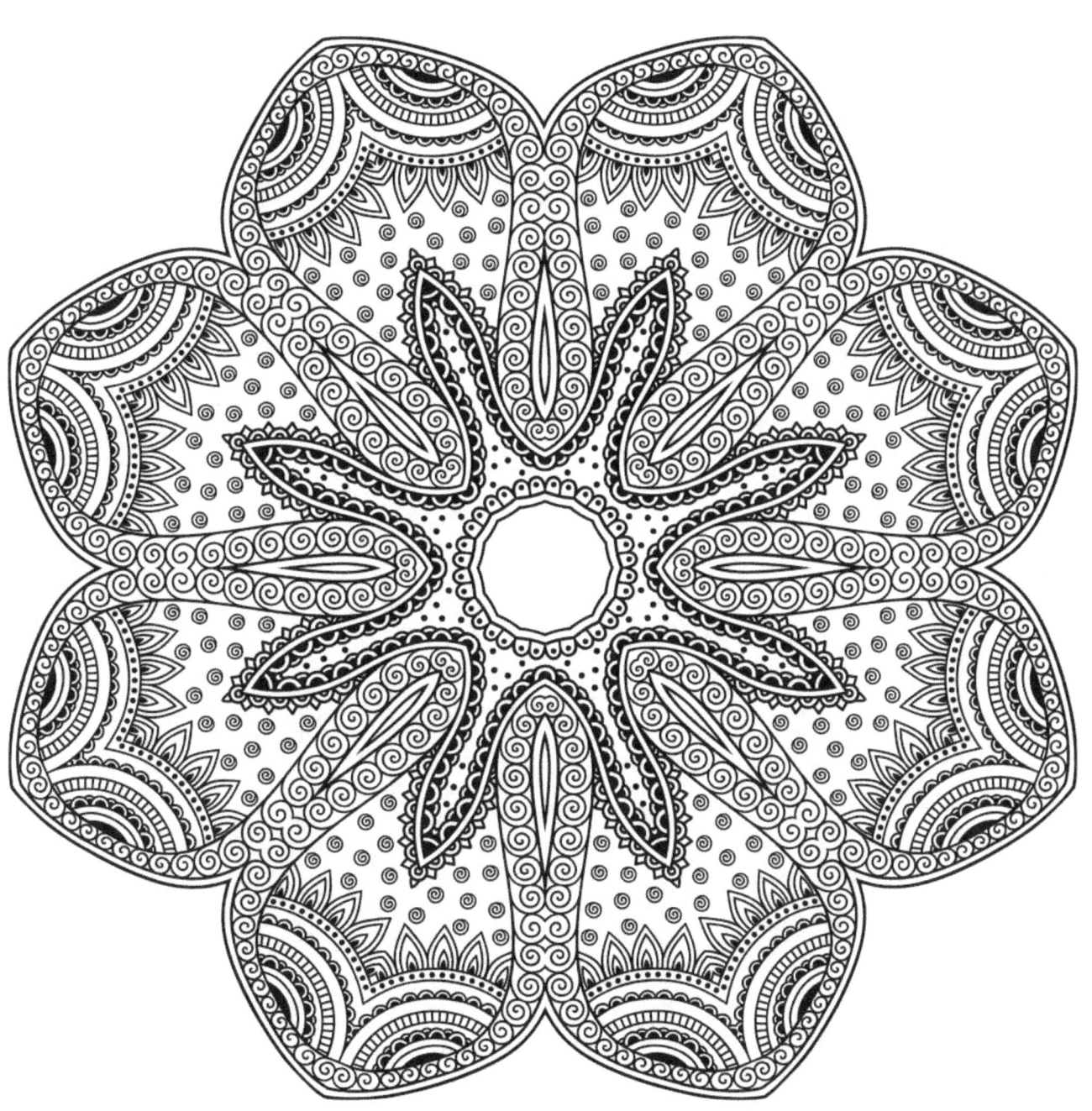

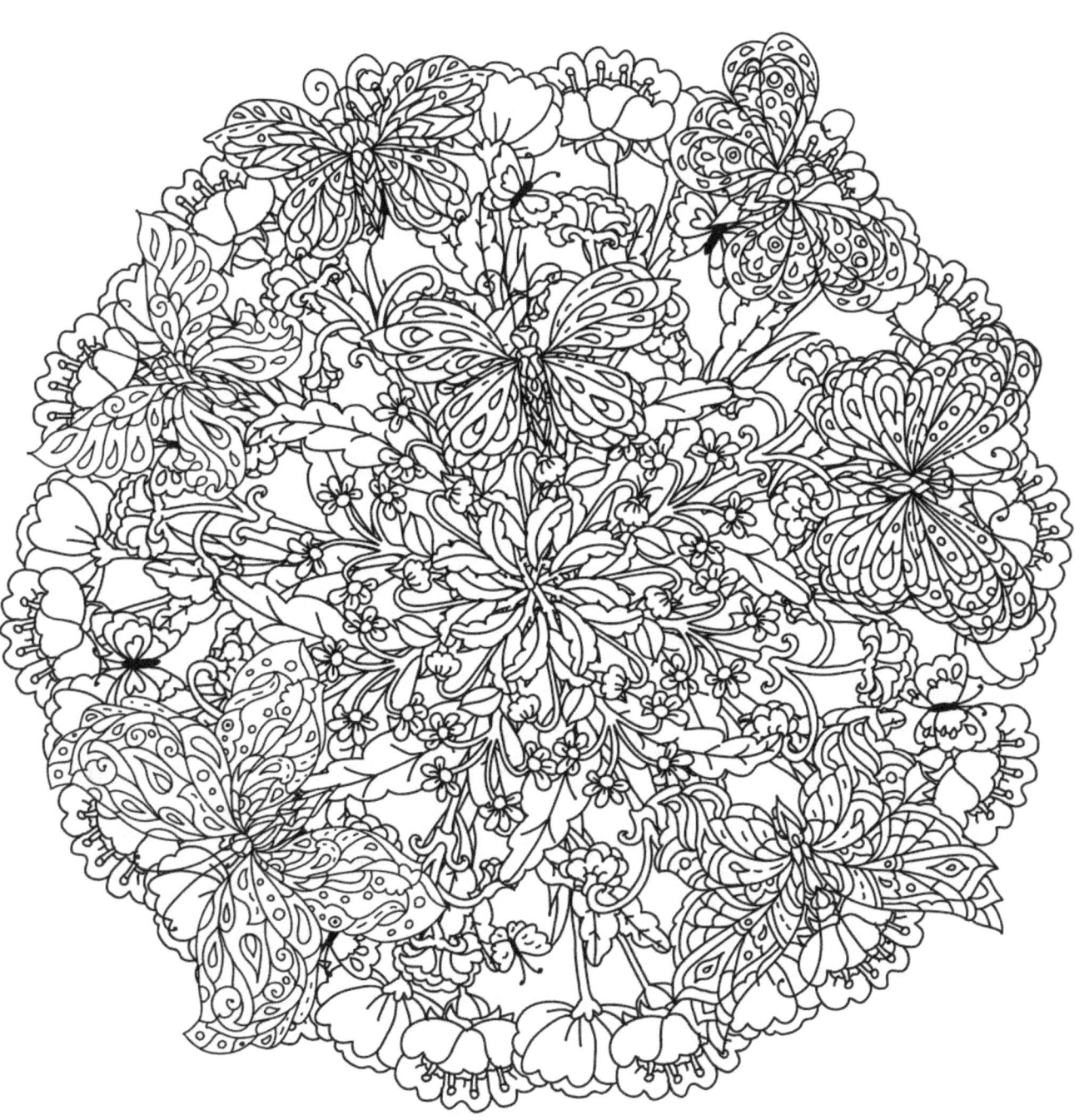

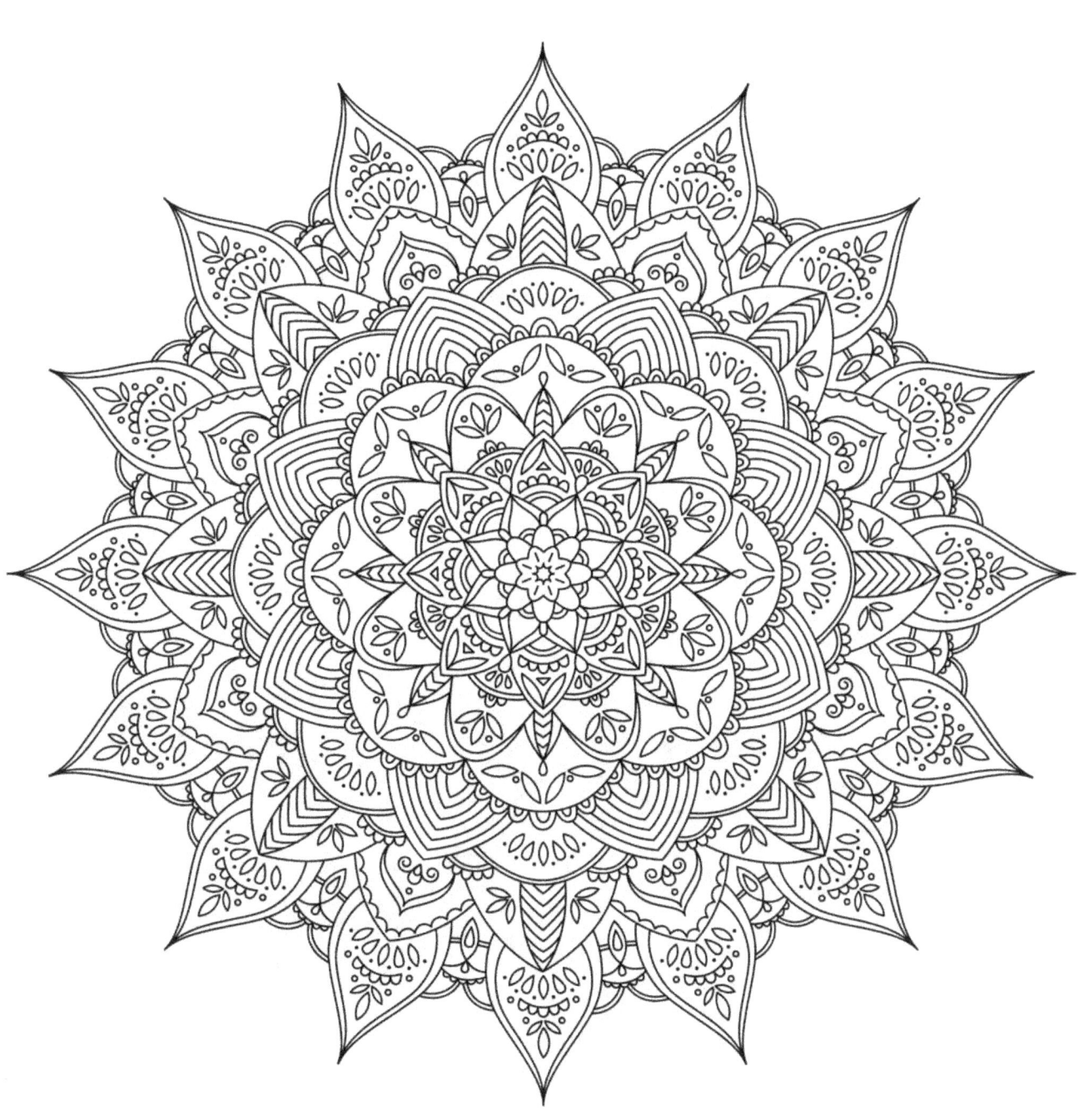

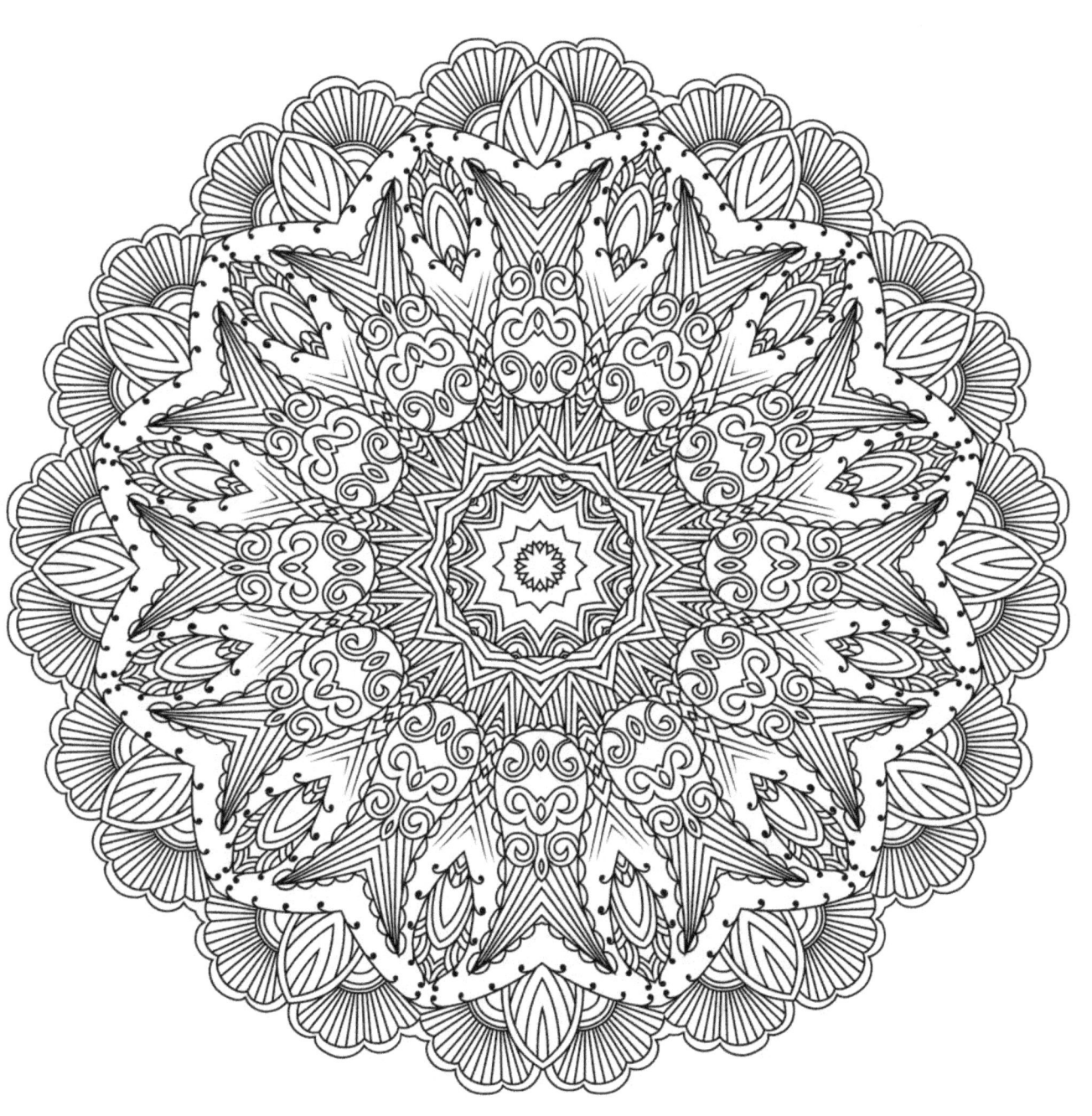

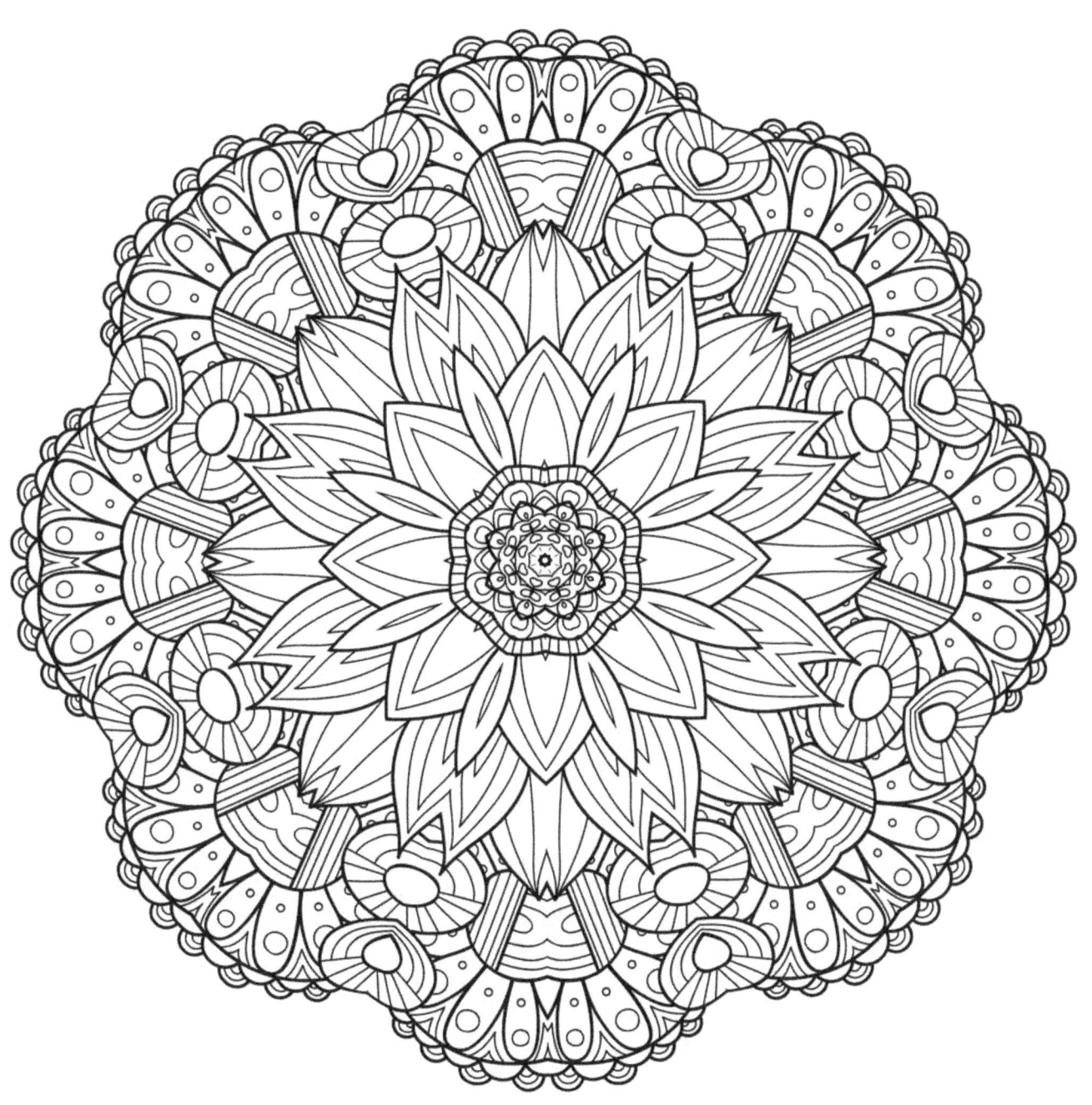

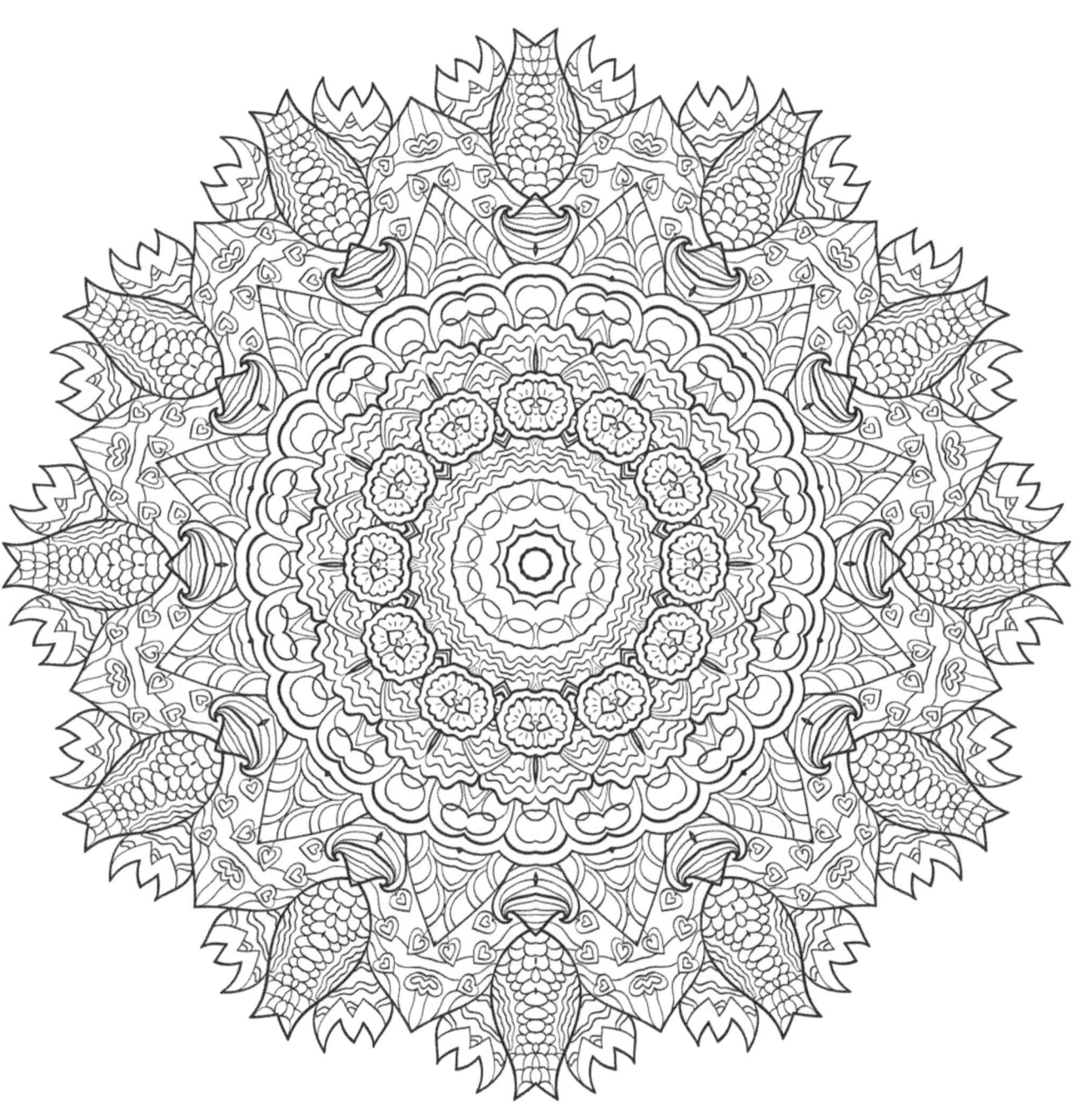

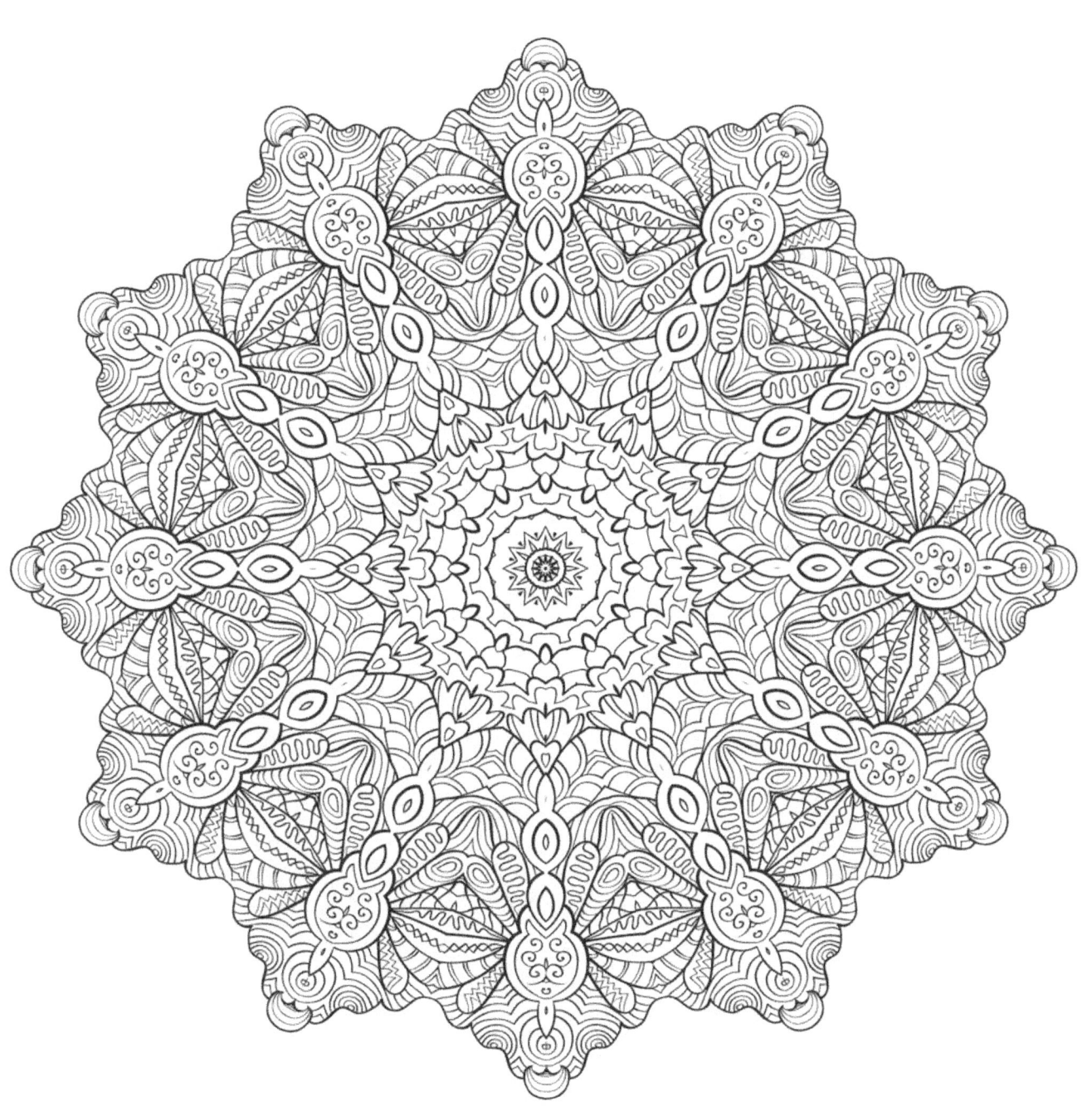

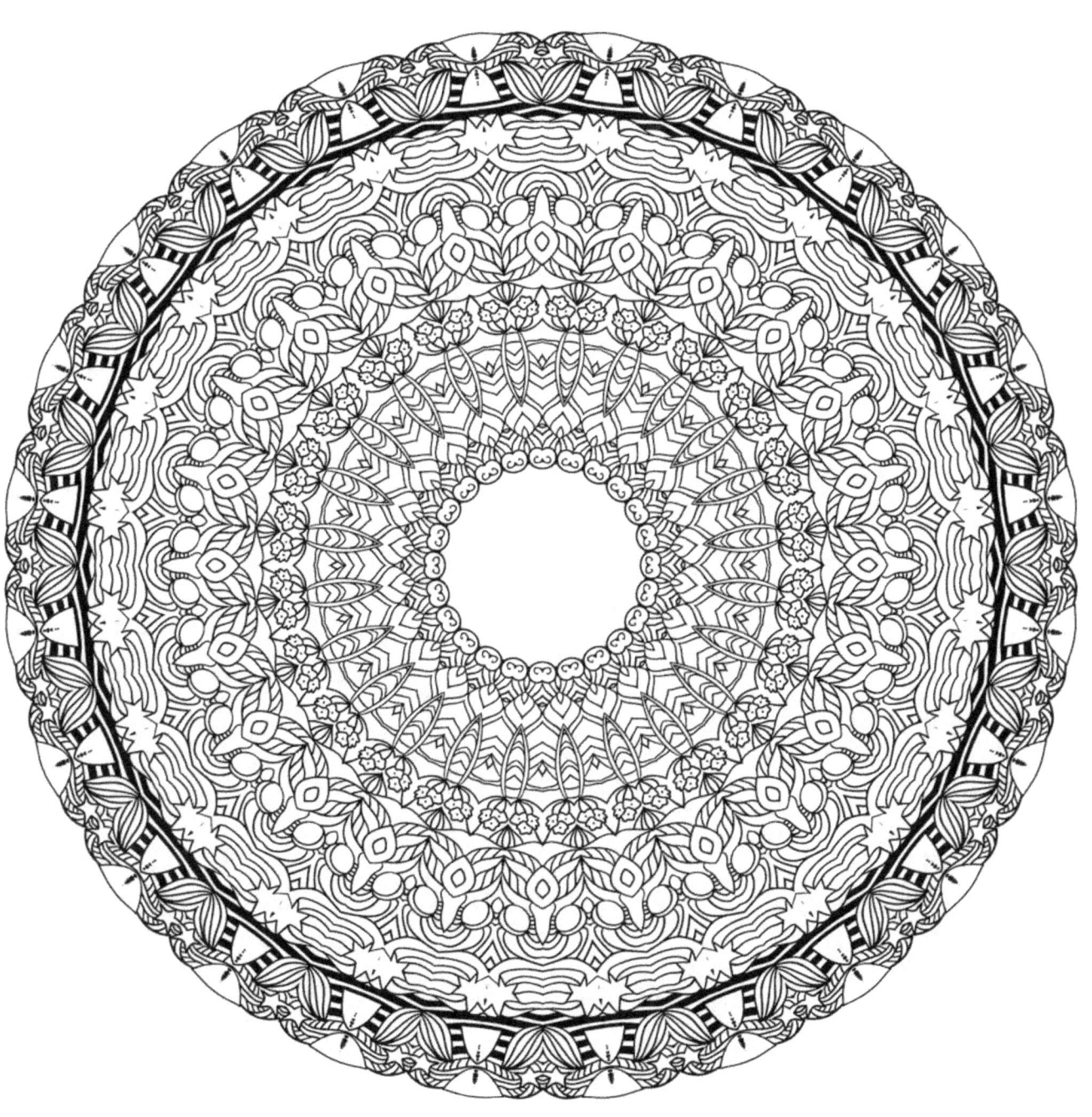

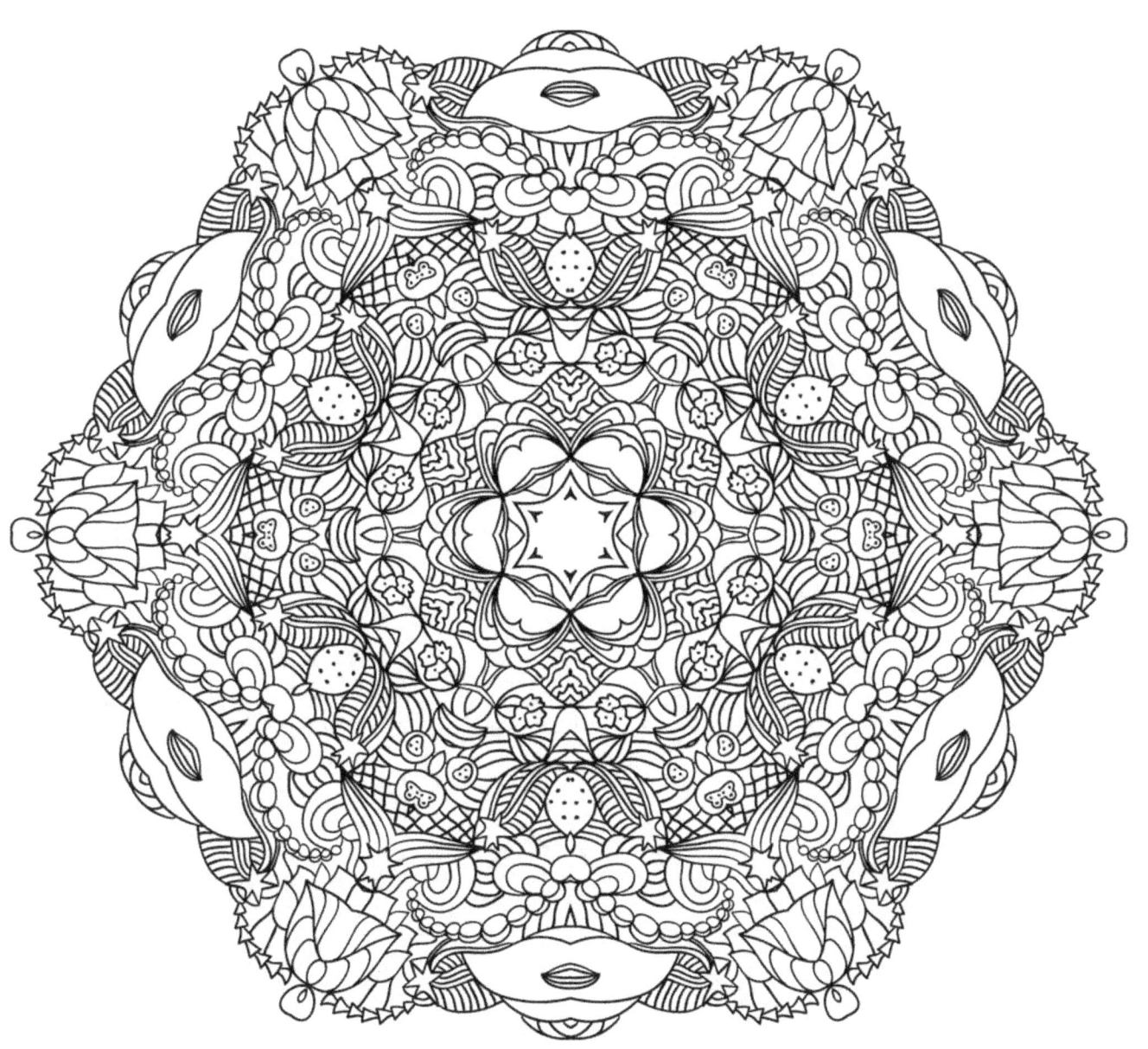

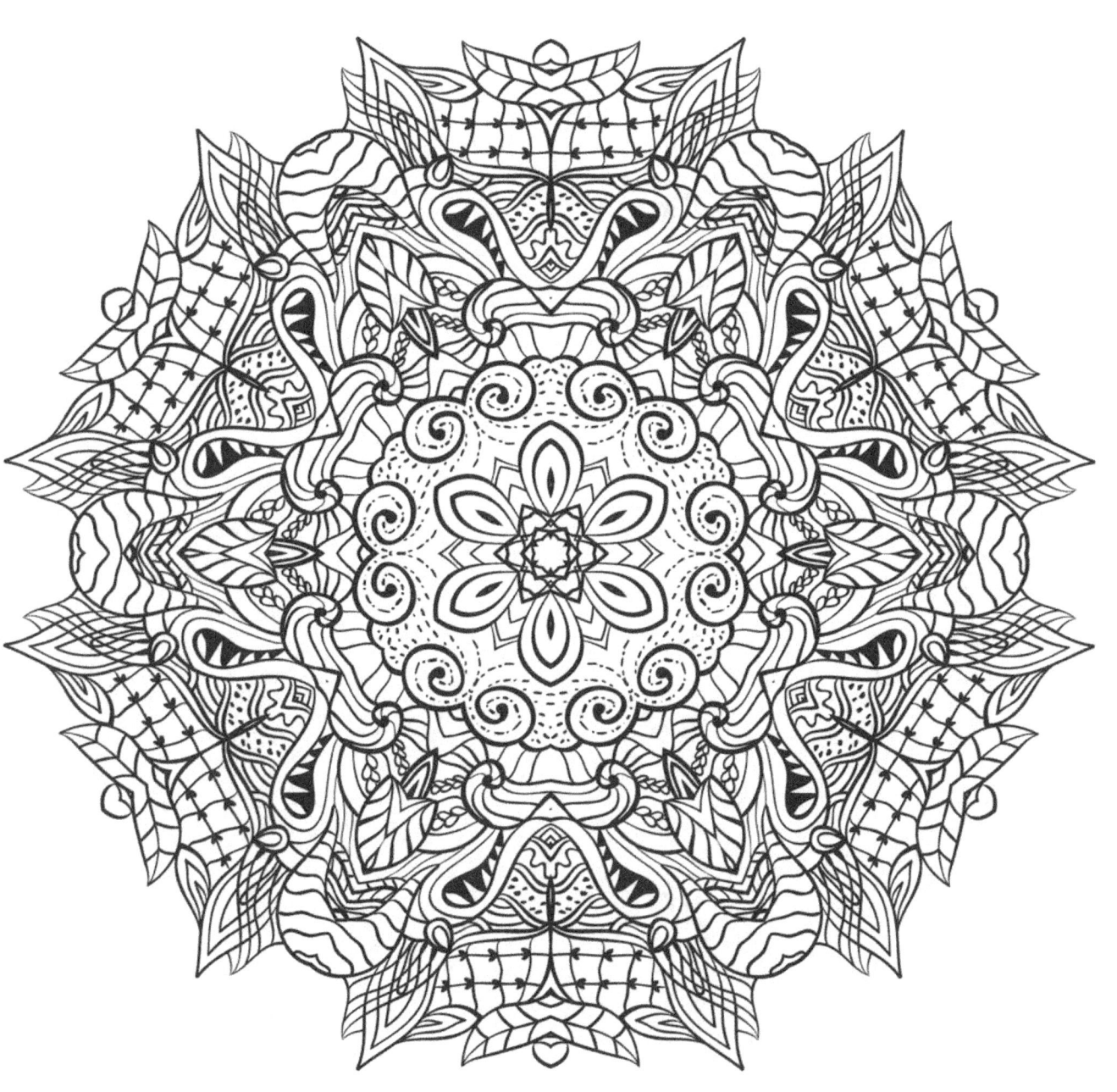

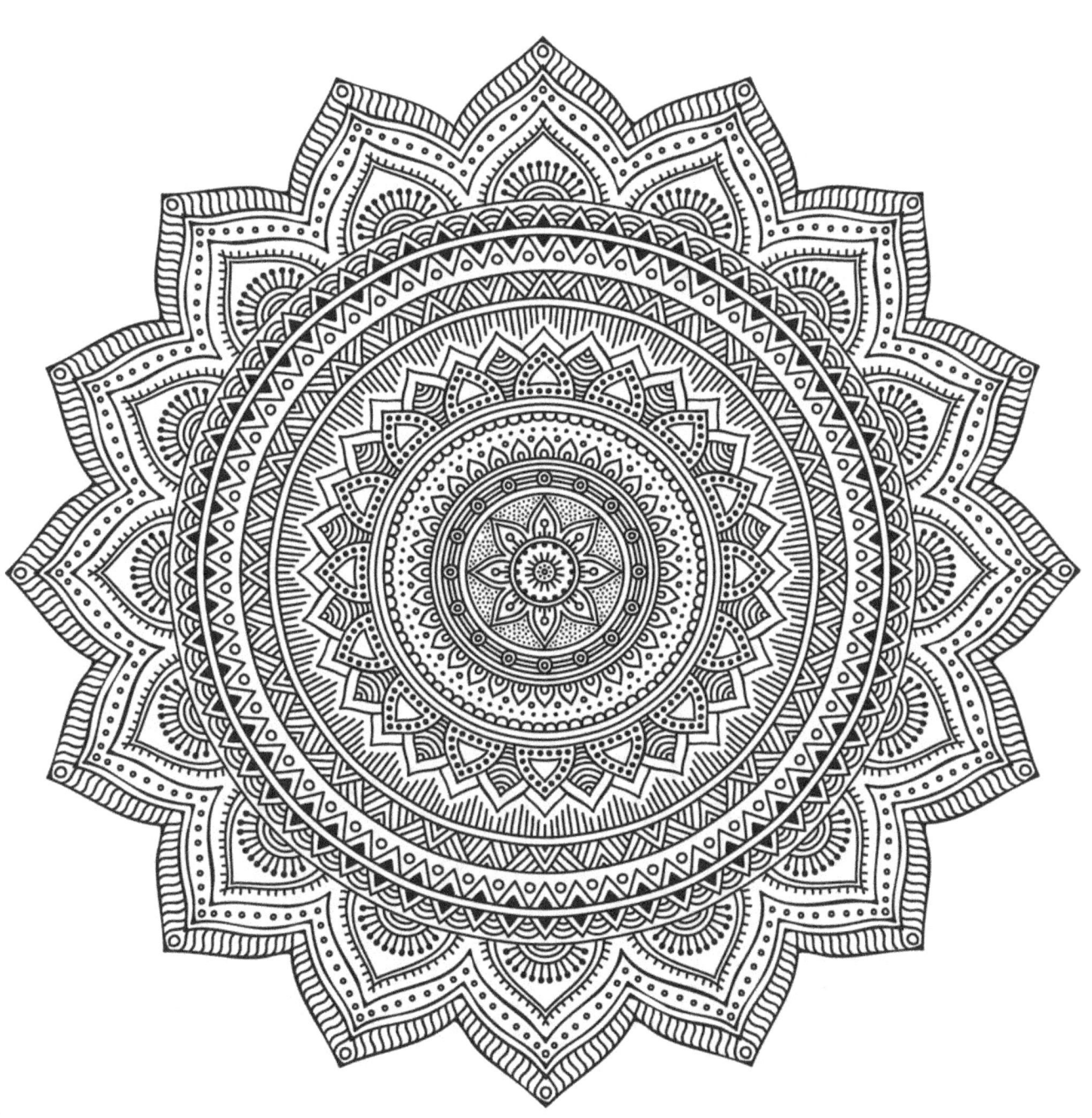

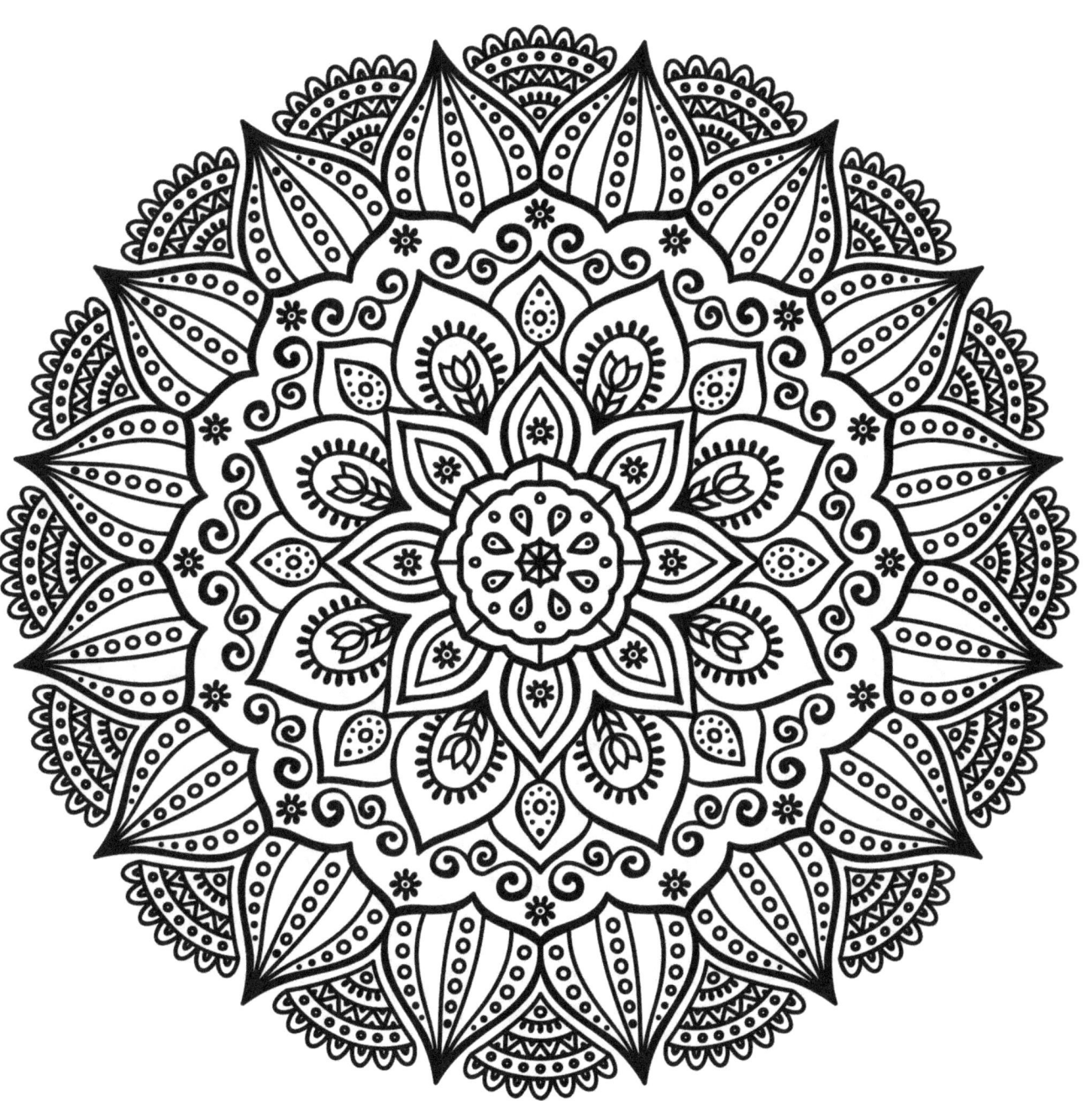

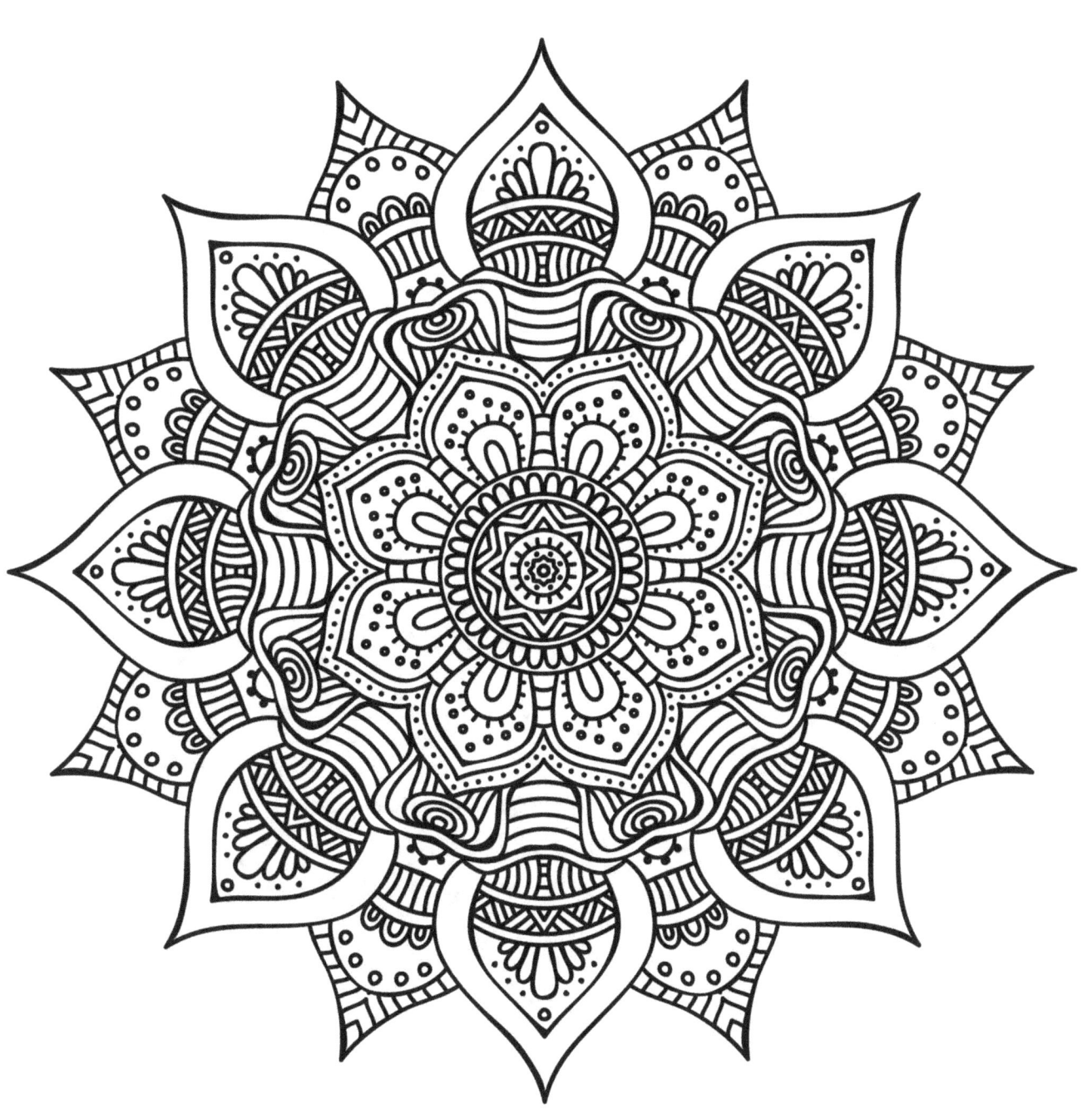

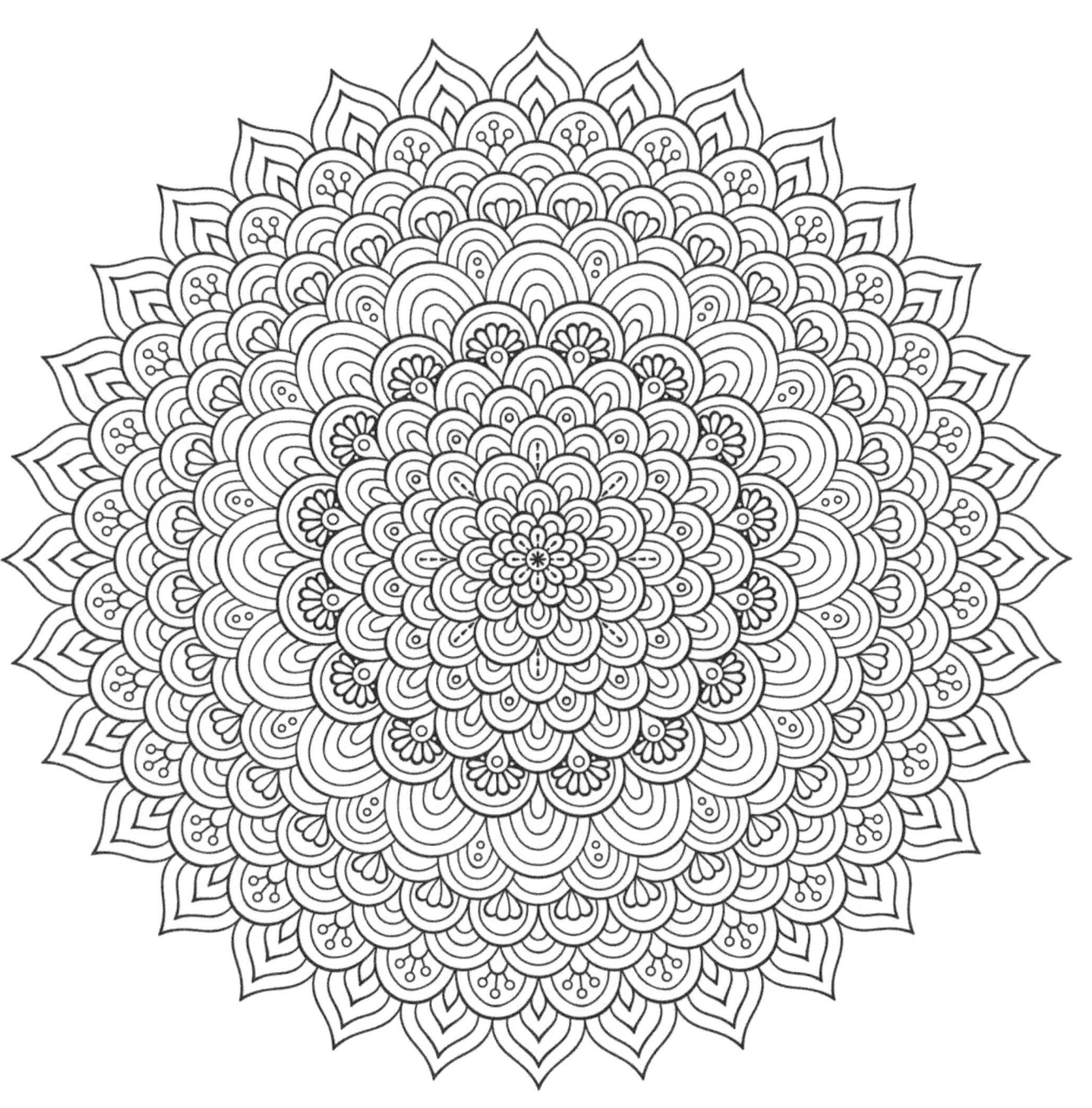

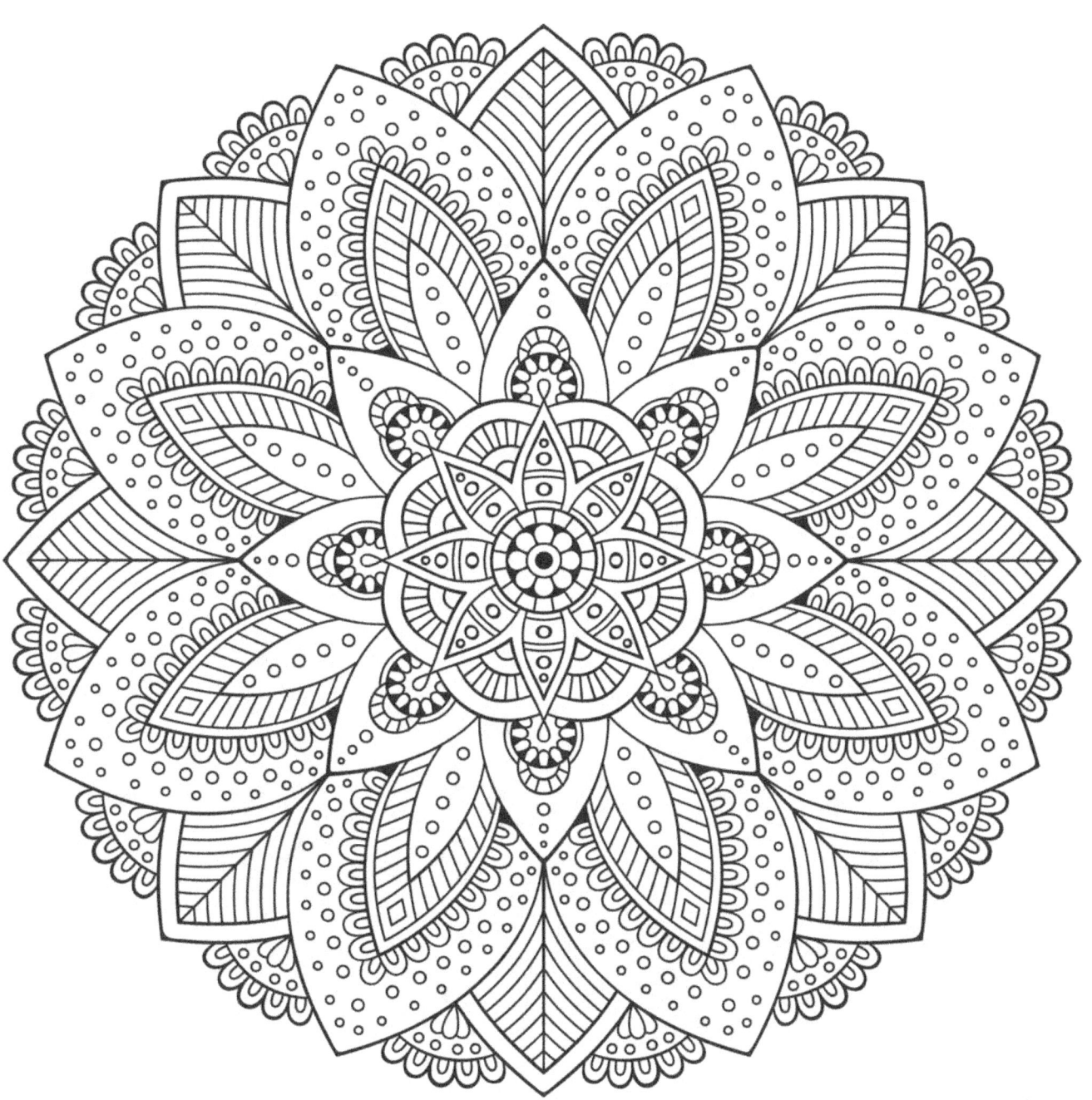

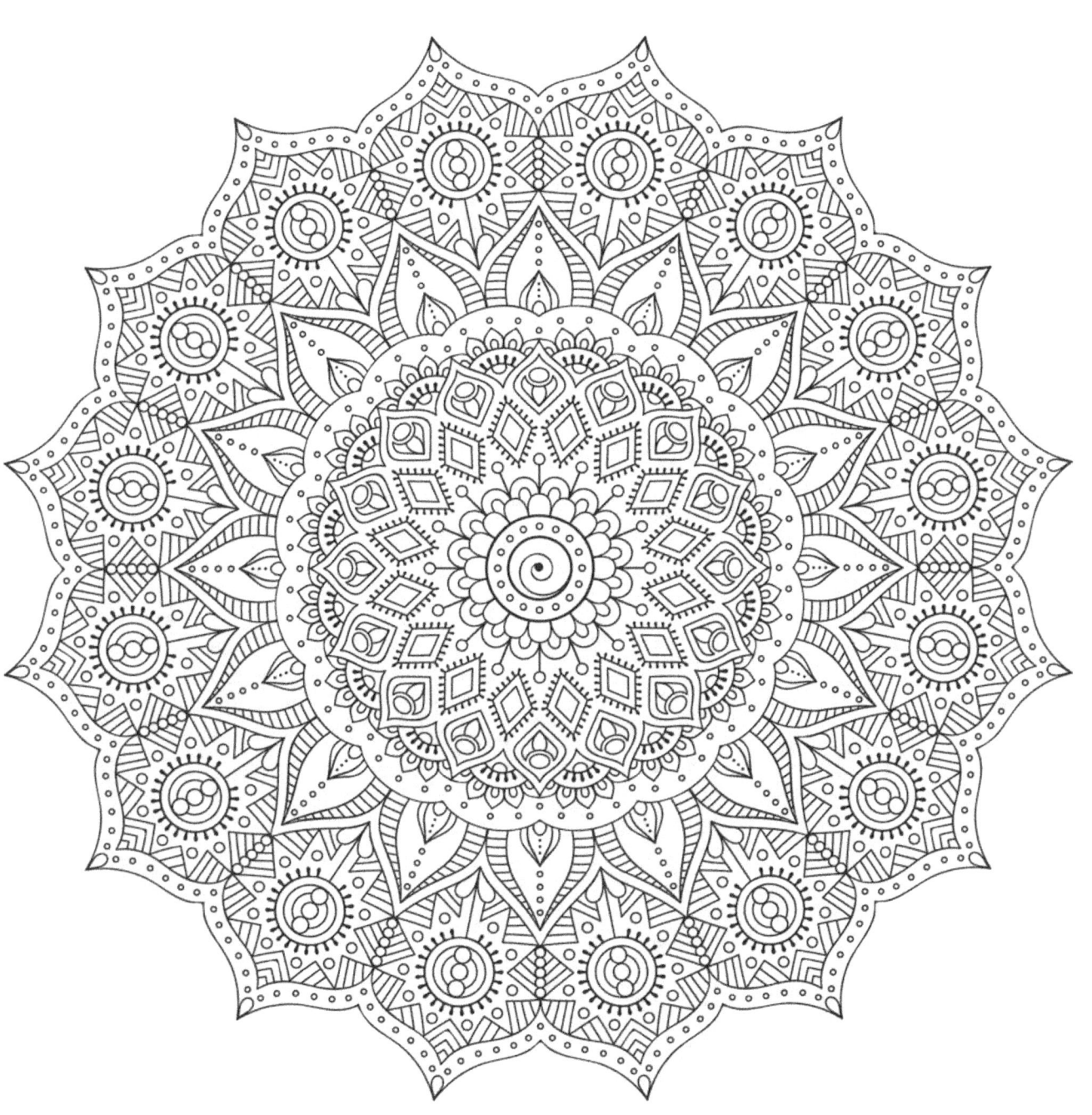

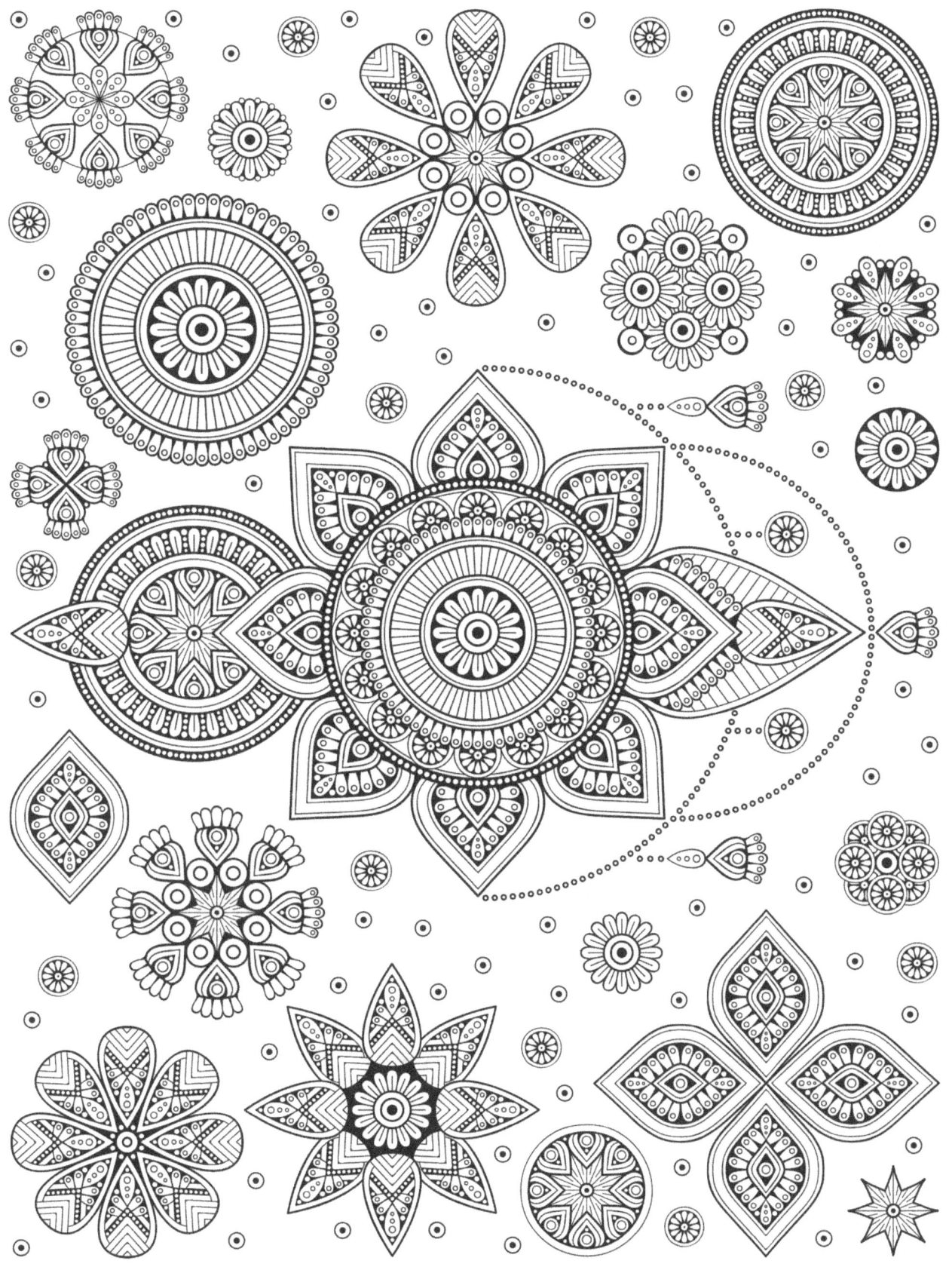

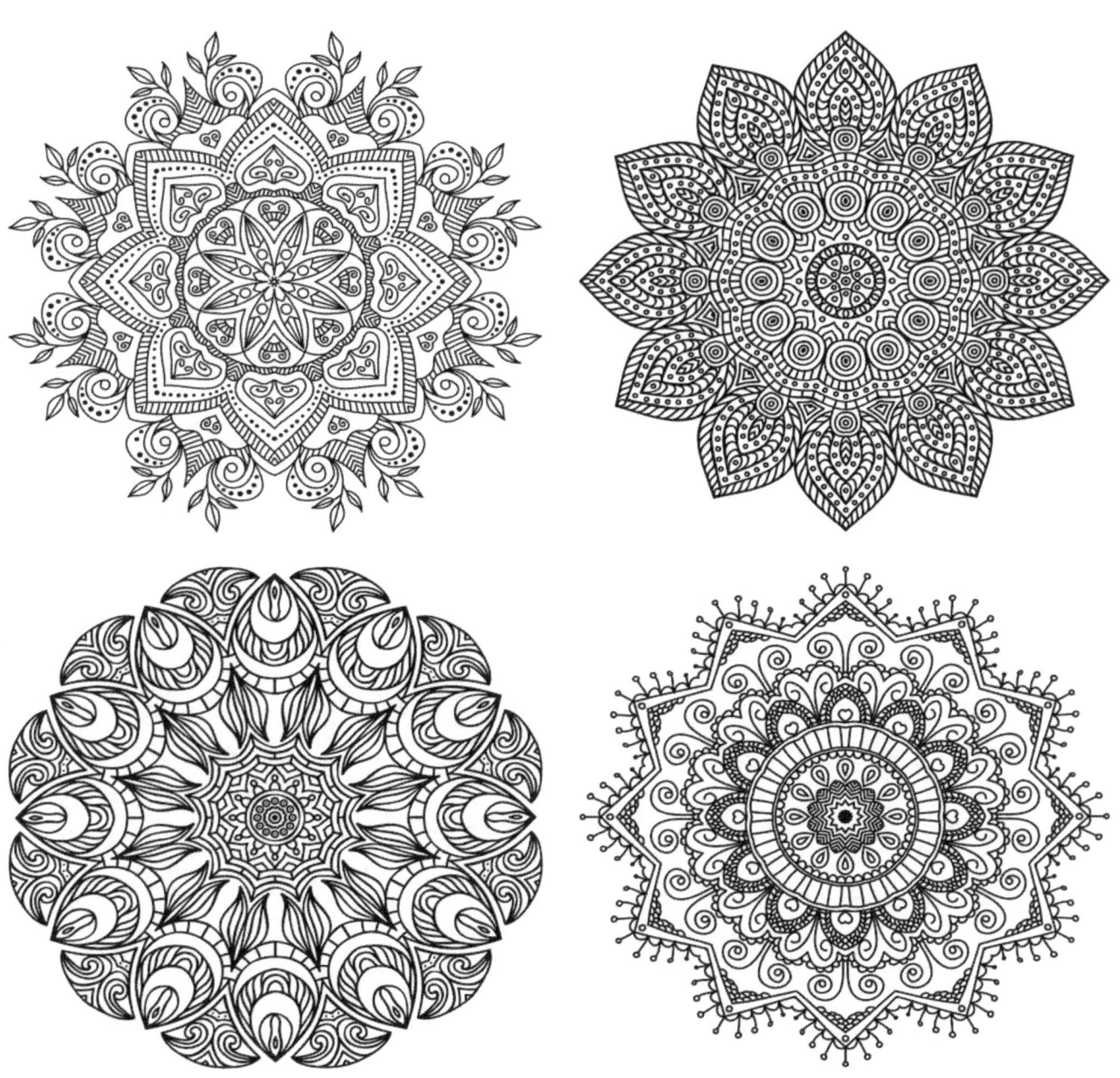

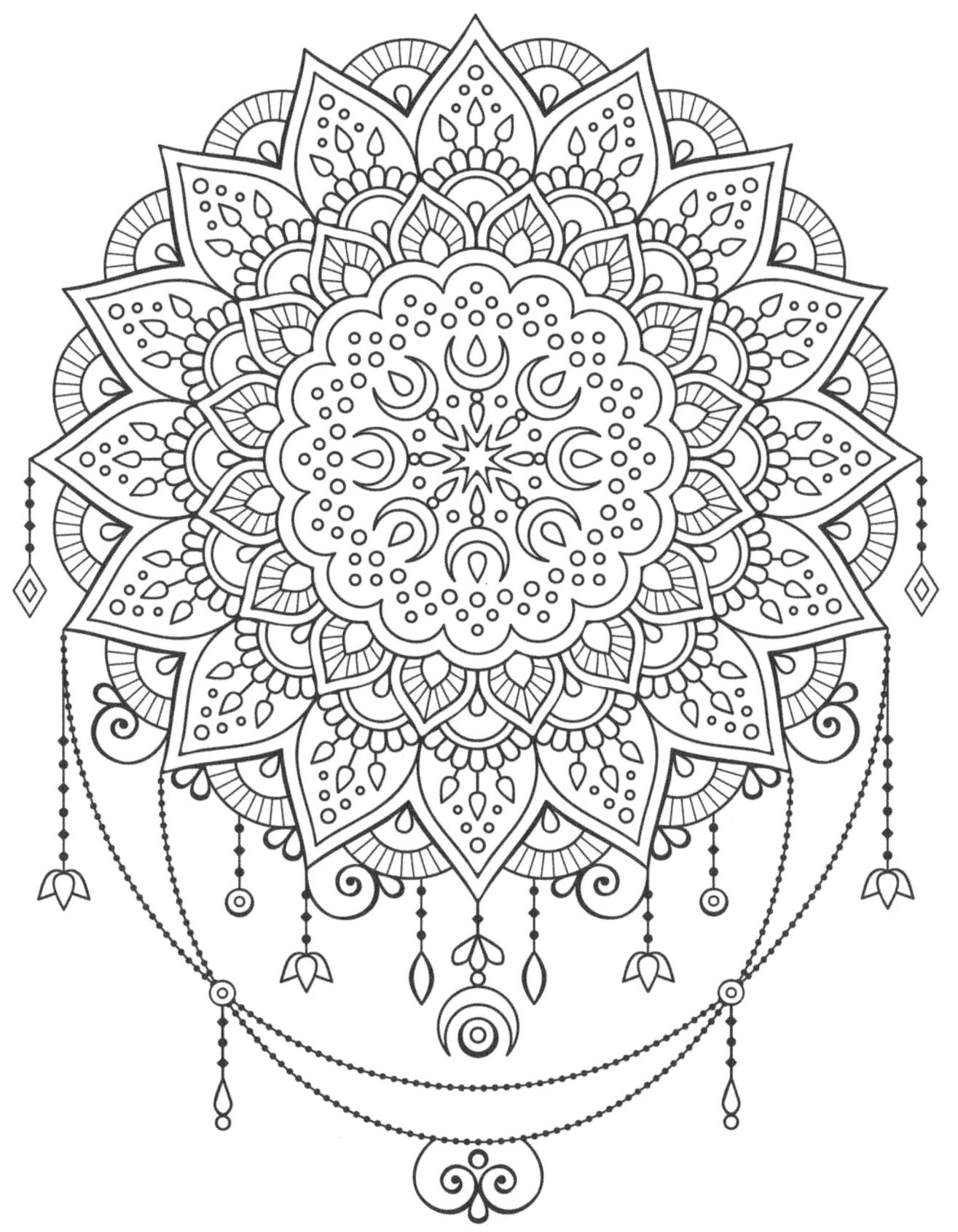

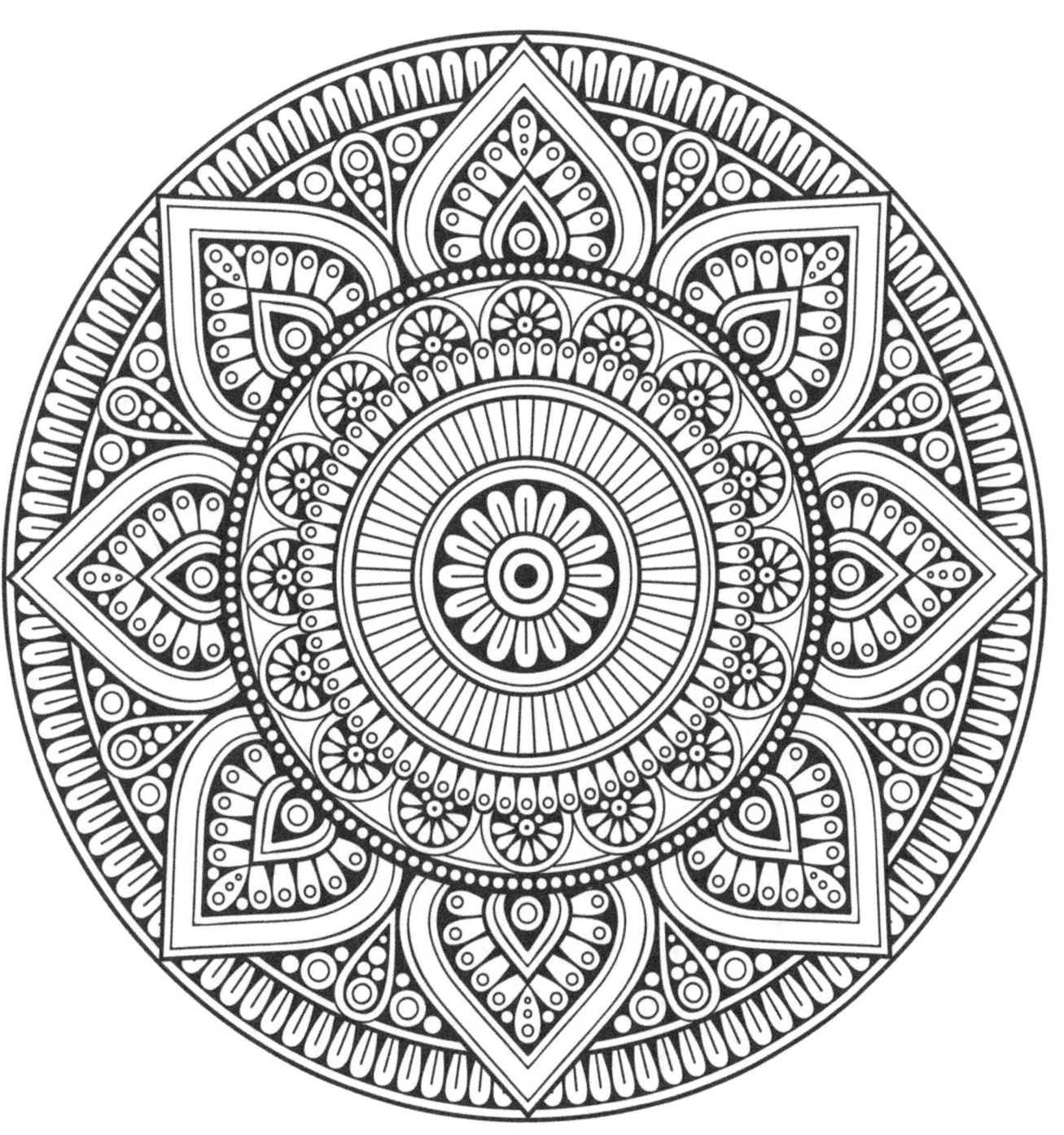

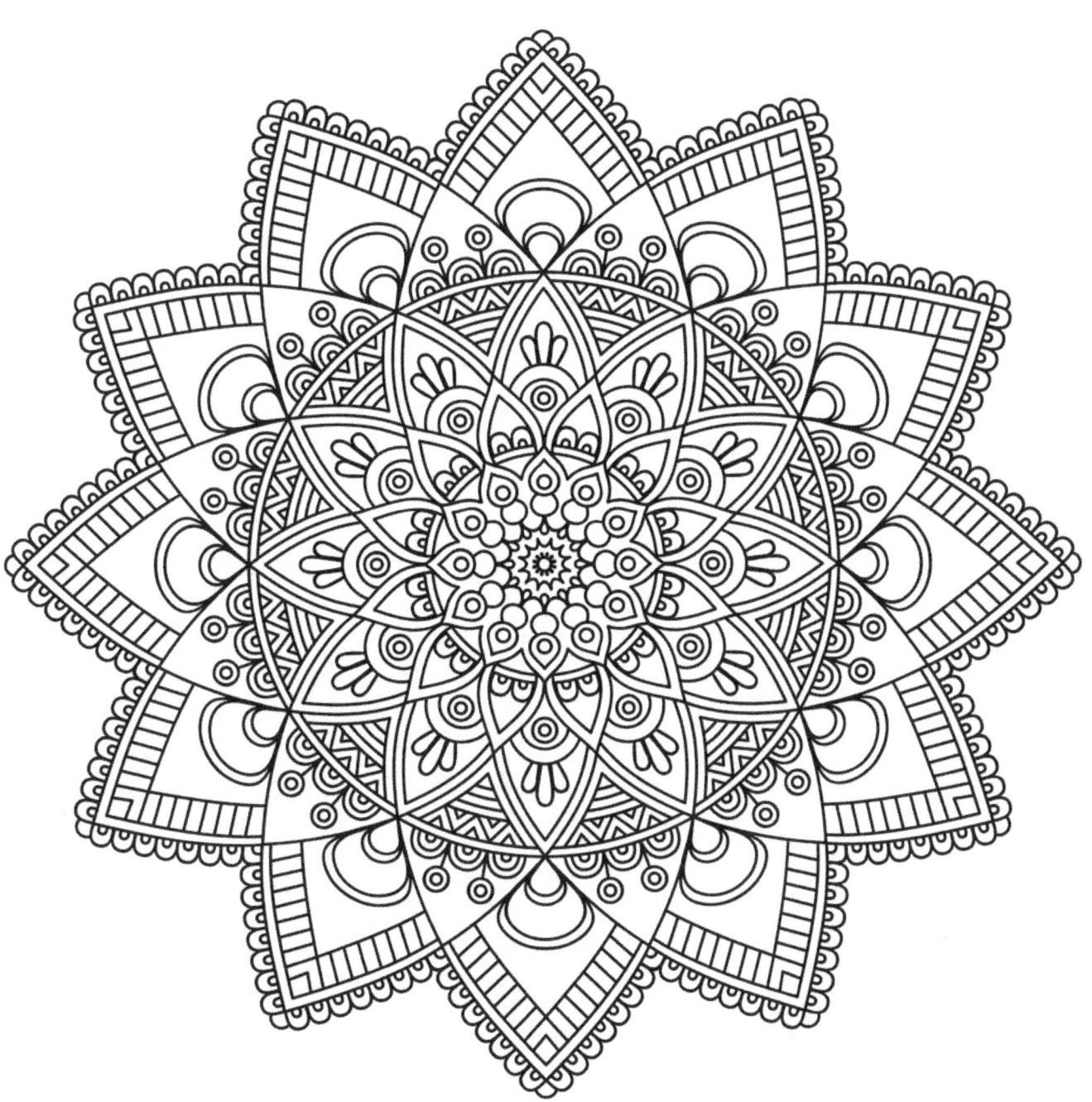

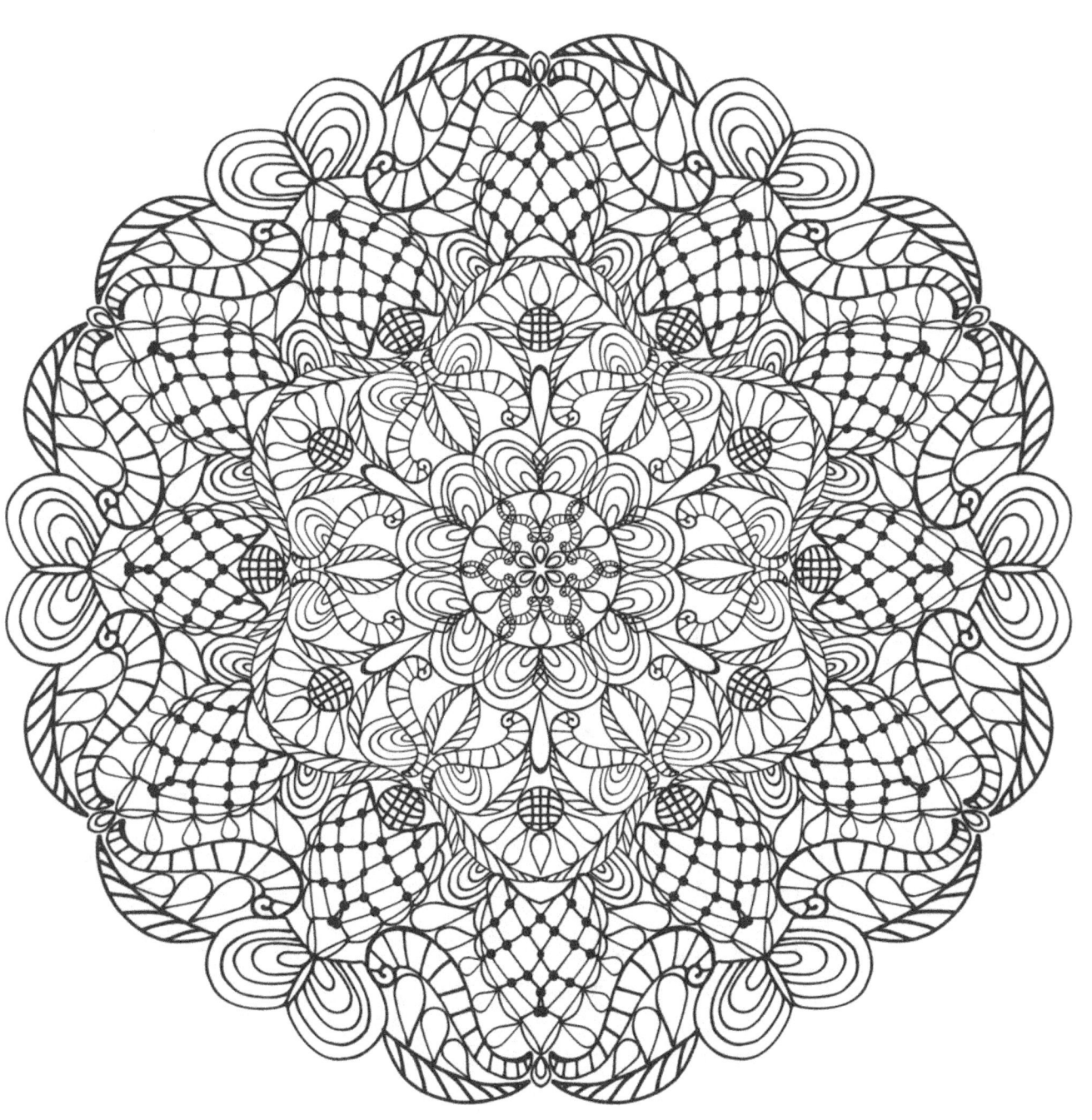

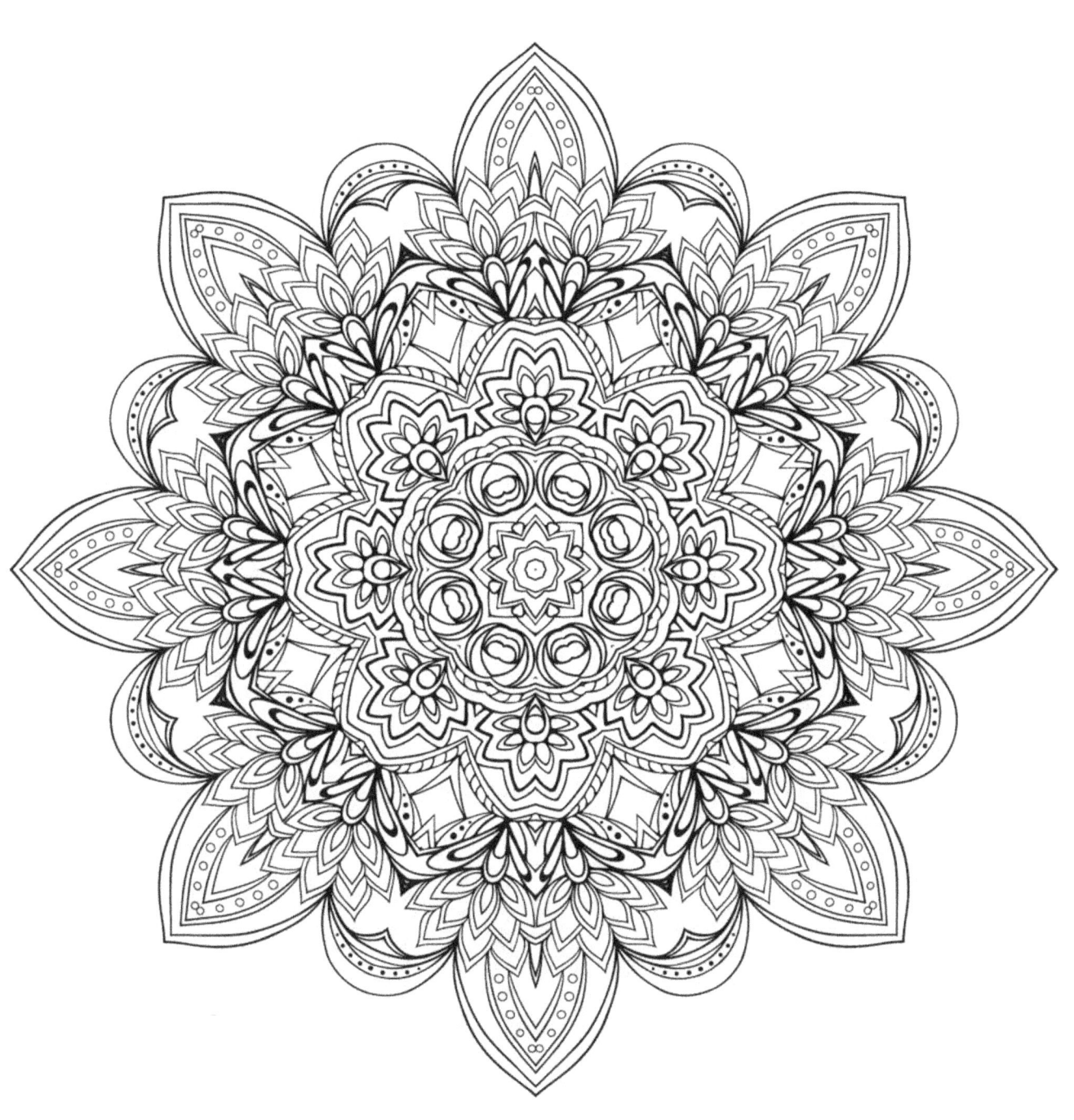

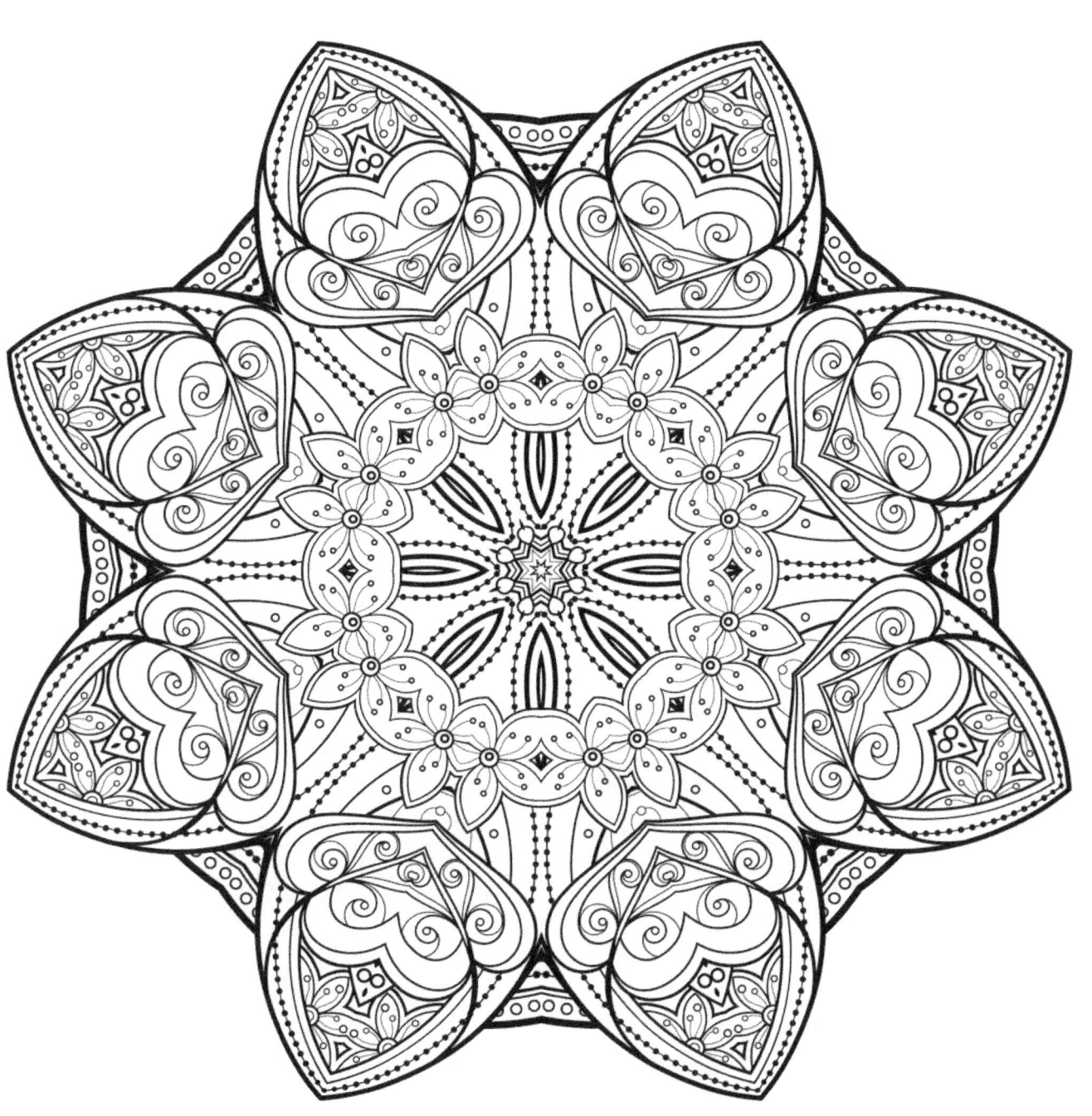

We believe that there are many talented people in this world, but most of them will never be known. Our goal is to give them a chance out there by sharing the beautiful work they do. All the designs in this book have been carefully selected from shutterstock with the agreement of each artist.
We hope that you have enjoyed their work as much as we do.

Special Thanks to all the artists who contributed to make this book so special.
Designs Copyrights:

Irina Krivoruchko, Julia Badeeva, Amovitania, An Vino, Anika Kodydkova, Anna Garmatiy, Art and Fashion, Fairy-N, Gal Amar, Galina Shpak, Genarik, Helen Lane, Helena Krivoruchko, Imageplus, Julia Snegireva, Katika, Lenkis_art, Mashabr, Miumi, Naticka, OlichO, Realiora, Snezh, Tatiana_Kost94, Yulianka
/shutterstock.com

www.ingramcontent.com/pod-product-compliance
Lightning Source LLC
Chambersburg PA
CBHW081607200526
45169CB00021B/2198